（汉英对照）

〔春秋〕孙　武　著
罗志野　选译

中国出版集团
中译出版社

图书在版编目（CIP）数据

孙子兵法：汉英对照 / 罗志野选译． -- 北京：中译出版社，2022.4
　　ISBN 978-7-5001-6596-5

　　Ⅰ.①孙… Ⅱ.①罗… Ⅲ.①兵法 - 中国 - 春秋时代 ②《孙子兵法》- 译文 - 汉、英 Ⅳ.① E892.25

中国版本图书馆 CIP 数据核字（2021）第 009804 号

出版发行 / 中译出版社
地　　址 / 北京市西城区新街口外大街 28 号普天德胜大厦
电　　话 / 010-68359719
邮　　编 / 100044
电子邮箱 / book@ctph.com.cn
网　　址 / www.ctph.com.cn

责任编辑 / 刘香玲　张　旭
文字编辑 / 赵浠彤
营销编辑 / 毕竞方
封面设计 / 黄　浩
内文制作 / 浩文博学

印　　刷 / 山东临沂新华印刷物流集团有限责任公司
经　　销 / 新华书店

规　　格 / 880 毫米 ×1230 毫米　1/32
印　　张 / 6
字　　数 / 160 千
版　　次 / 2022 年 4 月第 1 版
印　　次 / 2022 年 4 月第 1 次

ISBN 978-7-5001-6596-5　定价：52.00 元
版权所有　侵权必究
中　译　出　版　社

目录
CONTENTS

◇ 卷 上

002 计篇
Preliminary Calculations

012 作战篇
Waging War

024 谋攻篇
Offensive Strategy

034 军形篇
Dispositions

◇ 卷 中

048 兵势篇
Potential

058 虚实篇
Weakness and Strength

074 军争篇
Fighting for Military Advantage

090　九变篇
　　　Tactical Variables

098　行军篇
　　　The Army on the March

◇ 卷　下

120　地形篇
　　　Terrain

136　九地篇
　　　The Nine Varieties of Ground

166　火攻篇
　　　Fire Attack

172　用间篇
　　　Use of Spies

卷上

孫子兵法

计 篇①

(一)

孙子曰：兵②者，国之大事，死生之地③，存亡之道④，不可不察也。

◇ **白话译文**

孙子说：战争是国家的大事，关系到军队、国家的存亡，不能不认真考察研究。

① 计篇：此篇为首，故先定"计"——研究战争决策。用兵之道，始于计谋。
② 兵：在此篇中，指军事、战争。
③ 死生之地：战争场所，得其利者生，失其利者死。
④ 存亡之道：国家存亡之问题。

Preliminary Calculations

Sunzi said: What is war? It may be described as one of the most important affairs to the state. It is the ground[1] of death or life of both soldiers and people, and the way[2] that governs the survival or the ruin of the state. So we must deliberately examine and study it.

[1] Ground: Battlefield.
[2] Way: In ancient Chinese language "way" means law, principle, or reason.

（二）

故经之以五事，校之以计，而索其情①：一曰道②，二曰天，三曰地，四曰将，五曰法。

道者，令民与上③同意也，故可以与之死，可以与之生，而不畏危。

天者，阴阳、寒暑、时制④也。

地者，远近、险易、广狭、死生⑤也。

将者，智、信、仁、勇、严也。

法者，曲制、官道、主用⑥也。

◇ 白话译文

所以，要考察军事作战必须遵守的五项原则，在战争进行之前对敌我双方的优劣条件进行估算，以探索战争的情势：一是道，二是天，三是地，四是将，五是法。

所谓"道"，就是使民众与君主的意愿一致。这样，他们就可以为君主死，为君主生，而不畏惧危险。

所谓"天"，就是指昼夜阴晴、寒冬酷暑、春夏秋冬等自然环境变化情况。

所谓"地"，就是指路途的远近、地势的险阻、平坦地域的宽窄、死地与生地的利用。

所谓"将"，就是指将帅的才能，包括他的智谋、威信、仁慈、勇敢、严明。

所谓"法"，就是指军队的组织编制、将吏的管理、军需的供应。

① 故经之以五事，校之以计，而索其情：经，量度，即分析。校，比较，即需从五方面分析、比较及探索。
② 道：道路。此处指政治开明。
③ 上：指国君。
④ 时制：季节更替。
⑤ 死生：不可攻守进退或可攻守进退（之地）。
⑥ 曲：军队编制。制：指挥号令。官道：各级官吏之职责与管理。主用：军需配备与使用。

Therefore we should analyze and compare the conditions of ourselves and an enemy from five factors in order to forecast if we will win before the beginning of war. The five factors are as follows: the first is *way*; the second, *heaven*; the third, *earth*; the fourth, *generals* or *commanders*, and the fifth, *law*.

What is the *way*? The way may make the people in complete accord with their ruler in their goals and cause them to share weal and woe fearlessly during the war.

What is the *heaven*? The heaven means day and night, cold and heat, and the sequence of the seasons.

What is the *earth*? The earth signifies whether the battleground is distant or near, whether the terrain is strategically difficult or secure, vast or narrow, and whether conditions are favorable or unfavorable to the chance of survival.

What is the *general* or *commander*? The general or commander may be one who is a high-ranking military officer with five virtues: intelligence, trustworthiness, benevolence, courage, and sternness.

What is the *law*? The law refers to the military establishment, the assigment of officers at all levels, and the allocation and use of military supplies.

(三)

凡此五者,将莫不闻,知之者胜,不知者不胜。故校之以计,而索其情,曰:主孰有道①?将孰有能?天地孰得?法令孰行?兵众孰强?士卒孰练?赏罚孰明?吾以此知胜负矣。

◇ 白话译文

凡属于这五个方面的情况,将帅一般都应该知道。了解和掌握这些情况的就能胜利,不了解这些情况的就不能胜利。因此,要通过比较敌我双方情况,来探索战争的胜负。具体来说就是哪方君主更贤明?哪方将帅更有才能?哪方更得天时地利?哪方法令能得以贯彻执行?哪一方武器装备更精良?哪方士兵训练有素?哪方赏罚严明?我根据以上七个方面就可以判断谁胜谁负了。

(四)

将听吾计②,用之必胜,留之;将不听吾计,用之必败,去之③。

◇ 白话译文

将领听从我的计谋,运用它去指挥作战,必定能够取得胜利,那么可以继续担任将领;如果不听从我的计谋,作战一定失败,那他将领的职位将不保。

① 主孰有道:哪个君主更得人民支持。孰,谁,哪个,哪一方。
② 将听吾计:"将"指将军。但另一解释指孙子求吴王阖闾之语。即"如吴王听我计……"但从全文观之,宜释为"将领"。
③ 用之必胜,留之;将不听吾计,用之必败,去之:接上文之另一解释则为,用我计必胜,我将留下;不用我计必败,我即离去。

Whoever leads soldiers to fight must be familiar with the above-mentioned five factors. Only he who thoroughly understands them can win victory. If he is not well versed in these, he may be defeated. Therefore, in order to analyze and compare the conditions of the opposing sides according to a scheme to determine whether our side will win or not, the following questions should be asked:

Which ruler is the one who is popular with the people?

Which general is the one who has ability?

Which side has the more favorable climate and the advantageous terrain?

Whose discipline is more effective?

Which side possesses military superiority?

Which side has soldiers and officers that are better trained?

Whose system of rewards and punishments is fairer and clearer?

We may forecast the outcome of a battle if we have a careful consideration of them.

The general who adopts my schemes or stratagems will surely win while commanding at the front, and will surely retain his general's position. If he does not adopt my advice, he will certainly suffer defeat at the front, and will not keep his post.

(五)

计利以听①，乃为之势②，以佐其外。势者，因利而制权也③。

◎ 白话译文

采纳了有利的计谋了之后，还要制造有利的态势，来辅助外面的军事行动。所谓有利的态势，就是根据对自己有利的情况，掌握作战的主动权。

(六)

兵者，诡道④也。故能而示之不能，用而示之不用，近而示之远，远而示之近。利而诱之，乱而取之，实而备之⑤，强而避之，怒而挠之⑥，卑而骄之⑦，佚⑧而劳之，亲而离之。攻其无备，出其不意。此兵家之胜，不可先传也。

◎ 白话译文

用兵是一种诡诈的行为。所以，能打而装作不能打，要打而装作不要打，要向近处而装作向远处，要向远处而装作向近处。敌人贪利，就引诱它；敌人混乱，就攻取它；敌人力量充实，就要防备它；敌人兵力强大，就要避开它；敌人气势汹汹，就要阻挠它；装出卑微屈辱的样子，让敌人骄纵起来；敌人休整得好，就要拖垮它；敌人内部团结，就要离间它。在敌人毫无防备之处发动进攻，在敌人意料不到时采取行动。这是军事家指挥的奥妙，是不能预先传授的。

① 计利以听：采纳有利计谋之后。
② 乃为之势：创造一种积极的军事态势。
③ 因利而制权也：因事之利，制为权谋。
④ 诡道：诡诈之术。
⑤ 实而备之：对具实力之敌严加戒备。
⑥ 怒而挠之：激怒性格暴躁之敌人。
⑦ 卑而骄之：故作谦卑，使敌人骄傲松懈。
⑧ 佚：安逸。

The general, having paid attention to my useful schemes or stratagems, must establish his force which will help him realize his plan. What is force? It means that a general should formulate his tactics according to what is expedient.

Any military operation takes deception as its basic quality. A commander who is competent should pretend to be incompetent; he who is ready to use military force should pretend to delay his action; he whose troops draw near the enemy should make it seem as if his troops were still far away; and he whose troops are far away from the enemy should let the enemy believe he is drawing near. A good commander must offer a bait to allure the enemy who covets small advantages, capture the enemy when he is in disorder, take precautions against the enemy who has good preparation and substantial strength, evade for a time the enemy while he is strong, enrage the enemy who is hot-tempered, pretend to be weak in order to make the enemy arrogant or haughty, wear the enemy out if he has taken a good rest, and set one party against another within the enemy if they are united. A commander must understand how to attack where the enemy is unprepared, and hit when it is unexpected. All the above-mentioned is the key to military victory, but it is never possible to formulate a fixed plan beforehand.

(七)

夫未战而庙算①胜者，得算多②也；未战而庙算不胜者，得算少也。多算胜，少算不胜，而况于无算乎③！吾以此观之，胜负见矣。

◈ 白话译文

开战之前，"庙算"能够取得胜利的，是因为胜利的条件充分；开战之前就预计不能取得胜利的，是因为胜利的条件不充分。"庙算"周密才能胜利，"庙算"疏漏就难以取胜，何况不做"庙算"的呢？我们根据"五事""七计"来进行观察，谁胜谁败就可见端倪。

① 庙算：出师打仗乃大事，须于庙堂举行仪式，协商讨论，以测算战争胜负。
② 得算多：有利条件多。
③ 多算胜，少算不胜，而况于无算乎：有利条件多则胜，有利条件少则败，何况毫无有利条件呢。

It gives a general greater advantage to win to make military decisions in the temple① even before fighting a battle, and less advantage if he makes no military decision in the temple before doing battle. He who plans and prepares carefully will find himself in a favorable position and win victory; he who does so carelessly will find himself in an unfavorable position and win no victory. How much worse off it is for those who do not prepare carefully at all! In this way, we can see clearly who may win and who may lose.

① Make military decisions in the temple: Doing battle is a matter of vital importance to the nation; the generals must hold a ceremony for military actions and forecast the outcome of a war.

作战篇

（一）

孙子曰：凡用兵之法，驰车千驷①，革车千乘②，带甲③十万，千里馈粮④。则内外之费，宾客之用，胶漆⑤之材，车甲之奉⑥，日费千金，然后十万之师举⑦矣。

◇ 白话译文

孙子说：一般而言，要兴兵作战，至少要动用战车千辆，辎重车千辆，全副武装的士兵十万，并向千里之外运送军需粮饷，那么前方后方的军需开支，招待使节、策士的费用，用于武器保养维修的胶漆等器材费用，保养修补战车、甲胄的支出等，每天就要开支千两金银。按照这样的标准准备之后，十万大军才可出发上战场。

① 驰车千驷：驰，奔、驱。驰车，古代一种轻型战车。驷，古代称拉一辆车的四匹马为"驷"，后来引申为四匹马拉的一辆车为一驷。千驷即战车千辆。按照当时规定，每辆驰车配备步兵72人和披甲士官3人，共75人。千驷，共有官兵75000人。
② 革车千乘：革车，是专运粮食、器械等的辅助性兵车。这种车子是用皮革缝制的篷车，因此称为革车，也叫守车、重车、辎车。乘，辆。按规定，每辆革车有保管、打柴挑水、饲养各5人和炊事员10人，共25人。千乘，即四马革车1000辆，共有官兵25000人。
③ 带甲：佩戴盔甲的士兵，带甲是春秋战国时期步兵的通称。
④ 馈粮：运送粮食。
⑤ 胶漆：张预注曰，"胶漆者，修饰器之物也。"古代弓箭甲盾的保养维修都需要使用胶和漆。这里泛指制作修理武器装备所需的各种物资。
⑥ 车甲之奉：车辆、盔甲之保养及补给。
⑦ 举：可出发。

Waging War

Sunzi said: When you dispatch troops for a battle, you must consider you will require one thousand swift war chariots, one thousand heavy war chariots and one hundred thousand soldiers. Besides, you will require enough provisions for them to cover a thousand miles. Therefore it will spend one thousand pieces of gold a day for the expenditure both at home and on the front, for the entertainment of advisers and counselors, for the maintenance cost of materials such as glue and lacquer, chariots and armors. After you have had enough money, your hundred thousand bold warriors can go out to battle.

(二)

其用战也胜①,久则钝兵挫锐,攻城则力屈②,久暴师③则国用不足。夫钝兵挫锐,屈力殚货④,则诸侯乘其弊而起,虽有智者,不能善其后矣。故兵闻拙速⑤,未睹巧之久也。夫兵久而国利者,未之有也。故不尽知用兵之害者,则不能尽知用兵之利也。

◇ 白话译文

军队出兵作战,必须力求速胜,如果拖得太久,就会使军队疲惫,失去锐气,攻打城池时,兵力消耗也非常大。另外,部队长久出兵在外,也会让国家的财政发生困难,造成供给不足。如果军队因久战而疲惫不堪,锐气受挫,军事实力损耗巨大,国内物资匮乏,那么其他诸侯肯定会乘虚而入,趁火打劫。到了那个时候,即使是足智多谋之士也没有好办法来挽救危局了。所以,在实际作战中,只听说过将领稳扎稳打速战速决的,还没有见过擅长取巧持久作战的。战争旷日持久而能够给国家带来好处,这是从来没有过的事情。所以,不能详尽地了解用兵害处的人,也就不能全面地了解用兵的益处。

① 用战也胜:作战但求(速)胜。
② 屈:竭尽,穷尽。
③ 久暴师:长期领军于外。暴,同"曝"。
④ 屈力殚货:人力、财力枯竭。殚,枯竭。
⑤ 拙速:直截了当,迅速解决。

In military operations a long-drawn-out victory will make the whole army dull and tired out, and dampen the spirit and enthusiasm of the soldiers; a drawn-out siege of a city will exhaust their strength: a protracted campaign abroad will deplete the financial resources of the state. If the army is tired out, the soldiers' enthusiasm is dampened and their strength exhausted, and the state's treasury is depleted, the neighboring princes will take advantage of your difficulty and attack you and do you harm. By that time, not even an able or wise counselor can steer clear of danger to safety.

Though we have heard of criticism of a hasty campaign, we have never seen the cleverness in prolonging a war, and we have never heard a protracted war can benefit a country. It is obvious that he who doesn't fully understand the dangers inherent in military operations cannot fully master the method of conducting the army in a profitable way.

（三）

善用兵者，役不再籍①，粮不三载②。取用于国③，因粮于敌④，故军食可足也。

◇ 白话译文

善于用兵的人，不需要一再征集兵员，也不用多次运送军需粮饷，武器装备由国内供应，粮草则设法从敌人那里夺取，这样，军队所需要的物品和粮草都能够充分得到满足。

① 役不再籍：兵员不在一户中征集第二次。役，兵役。籍，户籍，即依户征募兵卒。
② 粮不三载：载，运载、运送。曹操注云："始载粮，后遂因食于敌，还兵入国，不复以粮迎之。"指出征时，第一次运粮至敌境，以后就因粮于敌，等到军队凯旋时，再运第二次粮食至国境迎接，不做第三次的运粮。
③ 取用于国：军需自国内运来。
④ 因粮于敌：粮草自敌国征用。因，依靠，凭借。

He who is adept in military operations never raises an army twice nor provides food again and again. He brings along military supplies from his own country, and obtains provisions in the enemy state. In this way, the whole army can be sufficiently provided with food.

（四）

国之贫于师者远输①，远输则百姓贫。近于师者贵卖②，贵卖则百姓财竭，财竭则急于丘役③。力屈、财殚④，中原内虚于家。百姓之费，十去其七；公家之费，破车罢马⑤，甲胄矢弩，戟楯蔽橹⑥，丘牛大车⑦，十去其六。

◇ 白话译文

国家之所以会因为作战而贫困，主要是因为军队远征，不得不进行长途运输，而长途运输必定会耗费大量的人力物力，百姓就会因此而贫困。而在军队驻扎的附近，物价必然会飞涨，物价飞涨，就会使得百姓财富贬值，财富贬值就会急于增加赋役。这样的连锁反应就会使得国家力量耗尽，财富枯竭，百姓空虚。如果说，一场战争使得百姓的财产耗去十分之七，国家的耗费，涉及范围更加广泛，包括车辆损坏，马匹疲劳，盔甲、甲胄、箭弩、兵戟、盾牌的补充以及运输用的牛和大车，也要损失十分之六。

① 国之贫于师者远输：远途运输，耗尽财力人力，使国家百姓贫困。
② 贵卖：(促使)物价上涨。
③ 丘役：春秋末以丘为单位的赋役，是新兴地主阶级的革新措施。据《周礼》记载：九夫为井，四井为邑，四邑为丘，四丘为甸。从西周至春秋，军赋不断增加，春秋时，丘出战马一匹、牛三头。丘为征收军赋的基层单位。此句话意思为国家财力枯竭，急于加重丘井之役。
④ 财殚：财竭。
⑤ 公家之费，破车罢马：公，诸侯。家，室。公家是指诸侯国的公室。破车，战车损坏。罢马，战马疲病。罢，同疲。
⑥ 甲胄矢弩，戟楯蔽橹：甲，护身的铠甲。胄，头盔。弩，用机括发箭的弓。戟，将戈和矛合为一体的古兵器。蔽橹，一种主要用于防卫的大型盾牌。这里泛指装备战具。
⑦ 丘牛大车：曹操注："丘牛，谓丘邑之牛。大车，乃长毂车也。"此言为牛拉的辎重车辆。

Generally, transporting supplies to a distant place will impoverish the state that dispatches troops to wage war. At the same time, it will render the common people destitute. Besides, the prices of commodities normally soar near the battleground or the area where the troops are stationed; and the high price will drain away the common people's financial resources; and the financial exhaustion will lead to urgent exactions. With such financial depletion, every household in the country is stripped bare, about seven-tenths of the people's wealth is spent, and six-tenths of the state's revenue is dissipated, with chariots broken, horses worn-out, weapons lost or worn, including armors and helmets, arrows and crossbows, halberds and bucklers, spears and shields, draught oxen and heavy wagons and the like.

（五）

故智将务食于敌①，食敌一钟②，当吾二十钟；萁秆一石③，当吾二十石。

◇ **白话译文**

因此，聪明的将帅会想办法在敌国征集粮饷，吃敌国的粮食一钟，相当于吃本国的二十钟；用敌国的草料一石，相当于用本国的草料二十石。

（六）

故杀敌者，怒也④；取敌之利者，货也⑤。车战得车十乘已上，赏其先得者。而更其旌旗，车杂而乘之，卒善而养之，是谓胜敌而益强。

◇ **白话译文**

所以，要使部队和士兵勇猛地冲锋陷阵，杀敌立功，就要想办法激励战士，增强他们的斗志；要使士兵奋勇争先抢夺敌人的武器物资，就要利用奖赏的方法。在车战中，凡是缴获战车十辆以上的，就要奖励首先夺得战车的人。夺得战车后，要立即把车上敌人的旗帜换成我方的旗帜，并尽快将缴获的战车编入我方车队，投入战斗，同时，对于俘虏的兵卒，也要善待他们，尽量令其转变成能为自己所用的力量，这就是"战胜敌人的同时也能壮大自己"的道理。

① 智将务食于敌：明智的将领务求于敌国就地取粮。
② 钟：春秋时容量单位。当时齐国容量分为两种单位：奴隶主公室的"公量"和新兴地主阶级的"家量"，公量一钟为六百四十升，家量一钟为一千升。
③ 萁秆一石：萁，同"其"，豆秸、草料。一石（dàn），计量单位，合一百二十斤。
④ 故杀敌者，怒也：激发对敌愤怒，故可杀敌。
⑤ 取敌之利者，货也：赏以财物，鼓励杀敌。

Hence a wise commander should strive to get provisions in the enemy state. The consumption of one *zhong*① of food from the enemy is equivalent to twenty *zhong* from his own land; and the consumption of one *dan*② of enemy fodder to twenty *dan* of his.

If you want to slay the enemy, you must first rouse the hatred of your soldiers for the enemy; if you want to obtain the enemy's property, you must first give your soldiers material reward. If your army captures ten chariots in a chariot battle, you must reward the first who took the enemy's chariot. Replace the enemy's flags and banners with your own and mix the captured chariots with yours. At the same time, you should treat the captives well and know how to choose them for the right positions. As the saying goes, " The more times you defeat the enemy, the stronger you will be!"

① *Zhong*: Ancient Chinese unit of dry measure for food.
② *Dan*: Ancient Chinese unit of dry measure for grain.

（七）

故兵贵胜，不贵久。

故知兵之将，生民之司命①，国家安危之主也。

◈ 白话译文

所以说，作战最重要的是取得胜利，最不利的是旷日持久。

真正懂得用兵之道、深知用兵利害的将帅，掌握着军民的生死，也是国家安危存亡的主宰者。

① 民之司命：人民命运之所系。

Military operations should aim at speedy victory and not prolonged campaigns.

Therefore, the commander who is versed in the art of war is the man to determine the people's fate and to control the nation's security.

谋攻篇

(一)

孙子曰：凡用兵之法，全国为上，破国次之①；全军②为上，破军次之；全旅③为上，破旅次之；全卒④为上，破卒次之；全伍⑤为上，破伍次之。

是故百战百胜，非善之善者也；不战而屈人之兵，善之善者也。

◈ 白话译文

孙子说：指导战争和用兵的法则是，不用杀戮或伤亡很小，就使敌方举国上下投降才是上策，而经过交战依靠杀戮而击破那个国家就次一等；不用诛杀，就使敌人全军屈服是上策，用武力击破他就次一等；不用诛杀，就使敌人全旅屈服是上策，击破他就次一等；不待诛杀，使敌人全卒屈服是上策，击破他就次一等；不待诛杀，使敌人全伍屈服是上策，击破他就次一等。

因此，百战百胜，还不能算作善于用兵的人中最优秀的，不用战争而使敌方屈服才是最善于用兵的。

① 全国为上，破国次之：上策为保全敌国而使之投降，攻破敌国为次策。
② 军：泛指军队，亦作为军队编制单位。《周礼·地官·小司徒》郑玄注："军，一万二千五百人。"曹操、杜牧注引《司马法》："一万二千五百人为军。"
③ 旅：《说文》："五百人为旅。"曹操注同。
④ 卒：古代兵制单位，百人为卒。卒长为百夫长。《周礼·地官·小司徒》："五人为伍，五伍为两，四两为卒。"
⑤ 伍：古代最基本的兵制单位，五人为伍。

Offensive Strategy

Sunzi said: The general principle of war is that making the whole state surrender is better than destroying it; subjugating the entire enemy's army is better than crushing it; making a battalion, a company or a five-man squad surrender is better than destroying them.

Therefore, winning one hundred victories in one hundred battles is not real excellence, while winning a victory and subduing the enemy without fighting is the highest excellence.

（二）

故上兵伐谋①，其次伐交②，其次伐兵，其下攻城。

攻城之法为不得已。修橹轒辒③，具器械，三月而后成；距闉④，又三月而后已。将不胜其忿而蚁附⑤之，杀士卒三分之一，而城不拔者，此攻之灾也。

故善用兵者，屈人之兵而非战也，拔人之城而非攻也，毁人之国而非久也，必以全争于天下，故兵不顿⑥而利可全，此谋攻之法也。

◇ 白话译文

因此，用兵的上策是破坏敌人的战略计谋，其次是挫败敌人的外交，瓦解敌人的盟国，再次是使用武力进攻，最下策是攻占对方的城池。

攻城是万不得已时才采取的办法。修造攻城用的侦察敌方的高台和掩护兵卒的兵车，准备攻城的器械，这些攻城应用的物品三个月才能完成；构筑攻城用的土山又要三个月才能堆起来。将帅因为久攻不胜，常常会忍不住焦躁愤怒，像驱使蚂蚁一样驱赶督促着他的军队去攻城，往往是兵卒损伤了三分之一，可能城池还是没有攻下来，这就是攻城的坏处。

所以善于指挥战争、用兵打仗的人，降服敌方的军队不用硬打，夺取敌人的城邑而不靠硬攻，摧毁敌国而不需要旷日持久的战争，务必用全胜的计谋争胜天下，这样我方军队不至于疲惫受挫，而且能够取得胜利，这些就是谋划进攻时所用的基本法则。

① 故上兵伐谋：用兵之道，以计谋取胜为上。
② 伐交：以外交手段瓦解敌人。
③ 修橹轒辒：橹，大盾。轒辒，古代的战车，用以攻城。
④ 距闉：修土山以越过城墙进攻。闉，通"堙"，土山。
⑤ 蚁附：士兵多如蚂蚁，缘城墙而上。
⑥ 顿：疲惫受挫。

Thus, the best policy for the military operations is to gain victory by means of strategy. Next best policy is to disintegrate the enemy's alliances by means of diplomacy; the inferior way is to launch an attack on the enemy; the worst way is to storm cities and seize territory.

Besieging cities is only the last resort because it takes about three months to make mantelets and shielded vehicles ready and to prepare the necessary arms and equipment: and it takes another three months to pile up earthen mounds against the city walls, If the commander cannot control his impatience and orders his soldiers to swarm up the city wall like ants, the result will be that one-third of them will be killed while the city remains untaken. This is, in fact, the calamity of attacking cities.

A commander who is well versed in military operations makes the enemy surrender without fighting, captures the enemy's city without storming it, and destroys the enemy's state without protracted military operations. He must gain complete victory all-under-heaven. Therefore, the principle of winning victories by way of stratagem is to triumph without wearing out the troops.

(三)

故用兵之法,十则围之①,五则攻之,倍则分之②,敌则能战之③,少则能逃之,不若则能避之。

故小敌之坚,大敌之擒④也。

◇ 白话译文

用兵的法则就是,有十倍于敌方的兵力就要包围敌人,迫使敌方屈服;有五倍于敌方的兵力就要进攻敌人,有两倍于敌方的兵力,就要设法分散敌人;同敌人兵力相等,就要善于抗击敌人的进攻;兵力比敌人少,就要躲避敌人,避免与敌人决战;各方面条件均不如敌人,就要果断撤退。

所以,弱小的军队如果不能逃不能避,只知硬拼坚守,就会成为强大敌人的俘虏。

(四)

夫将者,国之辅⑤也。辅周⑥则国必强,辅隙⑦则国必弱。

◇ 白话译文

优秀的将帅是辅佐君主的栋梁,将帅与国家君主的关系如同辅木与车轮的关系一样紧密,如果团结无间,则国家一定强盛;相互之间如果产生空隙,国家一定衰弱。

① 十则围之:如有十倍兵力则围困敌人。
② 倍则分之:兵力两倍于敌人则可夹攻。
③ 敌则能战之:势均力敌则奋力抗击。
④ 小敌之坚,大敌之擒:弱兵如固执坚战,必为强敌所擒。
⑤ 辅:车轮外的两条直木,用以增强车辐的承载力。用辅木来比喻辅佐皇帝的大臣。
⑥ 辅周:辅木和车轮之间紧密相连,喻为君主和将帅之间团结无间。周,周密。
⑦ 辅隙:辅佐有缺点。隙,有所缺。

Therefore, the law of using troops is to surround the enemy when your strength is ten times his; to storm the enemy when your strength is five times; to attack the enemy from two sides when you are twice as strong; to resist him if you equal your enemy; to know the way of retreat if you are less strong and to avoid the enemy if you are much weaker.

If the weaker battles on stubbornly without taking its strength into account, it will surely be conquered by the stronger.

The general assists the ruler in governing a nation. If he assists the ruler to govern the nation well, the nation will surely be powerful; if he does not assist the ruler to govern the nation well, it will certainly be weak.

（五）

　　故君之所以患于军者三：不知军之不可以进，而谓①之进，不知军之不可以退，而谓之退，是谓縻军②；不知三军之事，而同③三军之政者，则军士惑矣；不知三军之权，而同三军之任，则军士疑矣。三军既惑且疑，则诸侯之难至矣，是谓乱军引胜④。

◇ 白话译文

　　因此国君不利于军队的情况有三种：不懂得军队不可以前进时却硬叫它前进，不懂得军队不可以后退时却硬叫它后退，这样做就会束缚住军队的战斗力；不懂得军队的内部事情而干涉军队的行政，军士就会迷惑不解；不懂得用兵的权谋，而干涉军队的指挥作战，那么就会使将士产生疑虑。如果军队将士们产生疑惑和忧虑，消息传到各个诸侯国那里，他们就会乘机进犯，灾难就要到来了。这就是所谓的扰乱自己的军心，引来敌人，自找死路。

① 谓：使。
② 縻军：束缚军队。縻，束缚。
③ 同：(外行)干预。
④ 乱军引胜：自乱其军引敌取胜。

A ruler may bring great misfortune upon his army in three ways. Firstly, if he orders an advance not knowing that his army cannot go forward, or orders a retreat while being ignorant that his army cannot fall back, his orders will, of course, tie down the army. Secondly, if he interferes with the administration of the army without understanding the internal affairs of it, his action will, of course, baffle his officers and soldiers. Thirdly, when he interferes with the direction of the army without knowing the principles of military stratagem, it will, of course, raise doubts and misgivings in the minds of the officers and soldiers. This necessarily leads to their confusion and suspicion. Then, the princes will take the advantage of it and rise in revolt. This is what is meant by the saying, throwing his own army into confusion and paving the way for the enemy's victory.

（六）

故知胜有五：知可以战与不可以战者胜，识众寡之用者胜，上下同欲者胜，以虞待不虞者胜①，将能而君不御者胜②。此五者，知胜之道也。

◇ 白话译文

所以，从以下五种情况就能预知胜利：知道什么情况下可以与敌人打，什么情况下不可以与敌人打的，会胜利；懂得根据兵力多少而采取不同战法的，会胜利；君主、将帅、将士上下齐心协力的，会胜利；以预先有准备对付没有准备的，会胜利；将帅指挥能力强而国君不加牵制干扰的，会胜利。这五条，可以说是预知胜利的基本方法。

（七）

故曰：知彼知己者，百战不殆③；不知彼而知己，一胜一负④；不知彼不知己，每战必殆。

◇ 白话译文

因此说，既要了解敌人虚实，又要知道自己强弱，哪怕进行上百次战斗都不会有危险；不了解敌人而知道自己，胜败的可能性是一半对一半；既不了解敌人又不知道自己，那肯定是每战必败。

① 以虞待不虞者胜：有准备对无准备，自可得胜。
② 将能而君不御者胜：将帅有能力而君主不加干预者胜。
③ 殆：危殆，危险。
④ 一胜一负：或胜或负，无必胜之把握。

There are five circumstances which can make the commander win victory. He who knows when he may fight and when he may not will win; he who knows how to adopt the appropriate military art according to the number of his own troops and his enemy's will win; he whose general and soldiers can fight with one heart and mind will win; he who is well prepared while his enemy is unprepared will win; he who is a wise and able general and whom the sovereign does not interfere with will win. It is in these five circumstances that the way to victory is known.

So it is said that if you know both the enemy and yourself, you will fight a hundred battles without danger of defeat; if you are ignorant of the enemy but only know yourself, your chances of winning and losing are equal; if you know neither the enemy nor yourself, you will certainly be defeated in every battle.

军形篇[1]

(一)

孙子曰：昔之善战者，先为不可胜[2]，以待敌之可胜[3]。不可胜在己，可胜在敌。

故善战者，能为不可胜，不能使敌之必可胜。故曰：胜可知，而不可为[4]。

◇ 白话译文

孙子说：从前那些善于用兵打仗的人，总是首先能做到使自己不被敌人战胜，然后等待和寻求可能战胜敌人的时机。使自己不可能被敌人战胜，主动权完全掌握在自己的手中；是否可能战胜敌人，在于观察敌人是否有疏漏之处可乘之隙。

所以，善于用兵打仗的人，至少要做到自己不给敌人以任何可乘之机，但是不能保证就一定能够将敌人打败。所以，从这个意义上说，通过各方面可以预知到胜利，但是却不能强求。

[1] 军形篇：探索军事上双方攻守形势。
[2] 先为不可胜：先使己方不可被战胜。
[3] 以待敌之可胜：等待可战胜敌方之时机。
[4] 胜可知，而不可为：有准备则胜利可预见，但不可强求。

Dispositions

Sunzi said: In the past the skillful warriors first freed themselves from defeat by the enemy, and then awaited opportunities to destroy the enemy. To be invincible depends on one's initiative; to defeat the enemy depends on the enemy's errors.

Therefore, those skilled in war can make themselves invincible but cannot manipulate the defeat of the enemy. That is why it is said one may foretell a victory but cannot be sure to gain victory as one wishes.

（二）

不可胜者，守也①；可胜者，攻也②。守则不足，攻则有余③。善守者藏于九地之下④，善攻者动于九天之上⑤，故能自保而全胜也。

◇ 白话译文

当不可能战胜敌人时，则采取防守；可能战胜敌人时，则要进攻。采取防守战术，是由于取胜条件不足；采取进攻战术，则说明是取胜条件有余。善于防守的人，像藏匿于深不可知的地下一样，使敌人无形可窥；善于进攻的人，像行动于高不可测的天上一样，使敌人无从防备。只有这样，才能既保存了自己的实力，又能够取得彻底的胜利。

① 不可胜者，守也：无把握胜敌，则守。
② 可胜者，攻也：有把握胜敌，则攻。
③ 守则不足，攻则有余：防守是取胜条件还不充分，进攻是战胜敌人条件已具备。
④ 藏于九地之下：九指最大之数。意为深秘隐藏。
⑤ 动于九天之上：指攻势雷霆万钧，敌无法抵挡。

When there is no chance of winning, assume a defensive position; when there is a chance of victory, launch an attack. If the favorable conditions are insufficient, you should defend yourselves; if the favorable conditions are abundant, you should make an attack. Those skilled in defence should hide themselves as if under the ninefold earth; those skilled in attack should strike at the enemy as if from the ninefold heavens. Thus, they can, on the one hand, protect themselves and, on the other hand, win a complete victory.

（三）

见胜不过众人之所知①，非善之善者也；战胜而天下曰善，非善之善者也。故举秋毫②不为多力，见日月不为明目，闻雷霆不为聪耳。

古之所谓善战者，胜于易胜者也③。故善战者之胜也，无智名，无勇功，故其战胜不忒④。不忒者，其所措必胜，胜已败者也⑤。故善战者，立于不败之地，而不失敌之败⑥也。

是故胜兵先胜⑦而后求战，败兵先战⑧而后求胜。善用兵者，修道而保法，故能为胜败之政⑨。

◇ 白话译文

预见胜利所需要的常识，并不超过一般人的智力范围，算不上是高明中之最高明的。通过激烈残酷的战斗而取得胜利，就算是全天下的人都说好，也不见得是高明中最高明的。这就像能举得起秋毫算不上大力士，能看得清日月算不上明眼人，能听得到雷声也算不上耳朵灵敏，都是一样的道理。

古代那些所谓的善于打仗的人，几乎都是在容易取胜的条件下战胜敌人的。因此那些能征善战的将领虽然打了胜仗，却很难得到智谋的名声，也看不出勇武的功劳。他所取得的胜利，是能见微察隐，不会有丝毫差错的。之所以没有丝毫差错，是因为他的战略措施是建立在必胜的基础之上的，他所战胜的敌人是已经处于劣势。

① 见胜不过众人之所知：预见胜利但未超过常人可知。
② 秋毫：指鸟兽秋季更生之毫毛。形容极轻，举之并不费力。
③ 胜于易胜者也：好像胜利来得容易（其实是善战才取胜）。
④ 不忒（tè）：不出差错。忒，差错。
⑤ 胜已败者也：战胜败势已成的敌人。
⑥ 不失敌之败：不放过使敌人失败的机会。
⑦ 先胜：先准备好取胜的条件。
⑧ 先战：先打起来，侥幸求胜。
⑨ 修道而保法，故能为胜败之政：修明德政，坚守法制，即可掌握胜败之主动权。

A foresight of victory that does not exceed ordinary people's common sense, is not the acme of excellence. A victory that is won through fierce fighting and is universally praised is not the acme of excellence. He who can lift a very light hair is not the one with unusual strength; he who can see both the sun and the moon is not the one with keen sight; he who can hear a thunderclap is not the one with acute hearing.

It was said in ancient times that those skilled in war always defeated the enemy that could easily be conquered. That is just the point; those skilled in war and win victories have neither the reputation for their wisdom nor the merit for their valor. The reason why they are bound to win is that they have planned for the certainty of their victory and the enemy is already destined to defeat. As a result, he who is skilled in war always finds himself in an invincible position and, at the same time, he will be sure to miss no military opportunities to conquer the enemy.

所以，善于打仗的人．总是使自己立于不败之地，同时又不放过任何足以战胜敌人的机会。

　　因此，能打胜仗的军队，总是先有了必胜的把握，而后才同敌人作战；打败仗的军队，总是先同敌人作战，企图在作战中侥幸取胜。真正善于用兵的将帅，必须修明军规，确保法制严明，所以才能掌握胜败的决定权。

Thus, a victorious army is one that will not fight with the enemy until it is assured of the conditions for winning, while a defeated army is one that starts the fight first and expects to have victory later. He who is adept in military operations always understands the principles of war and adopts the correct policies, so that victory is entirely in his hands.

（四）

兵法：一曰度①，二曰量②，三曰数③，四曰称④，五曰胜⑤。

地生度⑥，度生量⑦，量生数⑧。数生称⑨，称生胜⑩。

◈ 白话译文

用兵之法有以下五点：一是"度"，即根据战地地形的险易、广狭、面积大小等情况，做出利用地形的判断；二是"量"，根据对战地地形的判断，估量战场容量的大小；三是"数"，根据战场容量的大小，估计双方可能投入的兵力的数量众寡；四是"称"，根据敌我双方可能投入兵力的数量，进行军事实力强弱的衡量对比；五是"胜"，根据双方兵力的对比，判断作战的胜负。

这五个方面是相伴相生的，缺一不可。交战的敌我双方都占有一定的土地，就产生了对地理形势的"度"；双方土地大小的"度"不同，就产生了人口、兵源多少的"量"；双方人口、兵源的"量"的不同，就会产生物产、资源多少的"数"；双方人力、物产多少的"数"不同，就产生了力量强弱对比的"称"；由双方实力对比，可以推测出战争的胜负形势。

① 度：度量、分析地理形势。
② 量：计量人力与物质资源。
③ 数：计算可动员的兵力多寡。
④ 称：权衡，比较。
⑤ 胜：推算胜负。
⑥ 地生度：交兵之先度量地理形势。
⑦ 度生量：按地理形势而知人、物力之强弱。
⑧ 量生数：按人、物力可知可动员兵力之多寡。
⑨ 数生称：按兵员多寡可衡量双方之实力。
⑩ 称生胜：以双方实力对比，可测知胜负形势。

There are five important elements in the military rules: the first is the topographic analysis and survey; the second is the calculation of manpower and material resources; the third, the calculation of numerical strength; the fourth, a comparison of military strength of one's own and of the enemy's; and the fifth, a foresight of victory or defeat.

An excellent general should understand how to analyze and assess the terrain according to the physical features of a battlefield; how to calculate the manpower and material resources of both his side and the enemy according to the topographic analysis and survey; how to calculate the numerical strengths of both sides according to the manpower and material resources; how to compare the military strengths of his side and the enemy according to the numerical strengths, and how to estimate the outcome, win or lose, according to the military strengths of the opposing sides.

(五)

故胜兵若以镒称铢①,败兵若以铢称镒。胜者之战民②也,若决积水于千仞③之谿④者,形也。

◇ 白话译文

所以,胜利的军队对失败的军队来说,就好比处于以镒称铢的绝对优势地位;失败的军队对胜利的军队来说,就好比处于以铢称镒的绝对劣势的地位。胜利者在指挥军队打仗的时候,就像从几千尺的高处掘开溪中积水一样奔流直下,具有雷霆万钧之力,其势猛不可当,这也是强大军事实力的表现。

① 以镒称铢:镒,古代重量单位,合24两,言其重。铢,古代重量单位,24铢为一两,言其轻。此处指实力悬殊。
② 战民:士兵。
③ 仞:古代长度单位,八尺为一仞。
④ 谿:同"溪"。

A victorious army is like one *yi*[①] balanced against one *zhu*[②], while a defeated army is like one *zhu* balanced against one *yi*. The former has an obvious advantage over the latter. A general who will certainly win commands his men to fight with a force like the bursting of pent-up waters pouring down from a stream ten thousand feet high. This is the disposition of actual military strength.

① *Yi*: An ancient Chinese unit of weight, one *yi* is 24 *liang* (1 *liang* = 50 grammes) .
② *Zhu*: An ancient Chinese unit of weight, one *zhu* is equal to 1/24 *liang*.

卷中

孙子兵法

兵势篇①

（一）

孙子曰：凡治众如治寡，分数②是也；斗③众如斗寡，形名④是也；三军之众，可使毕受敌而无败者，奇正⑤是也；兵之所加，如以碫⑥投卵者，虚实⑦是也。

◇ 白话译文

孙子说，要做到治理人数多的军队像治理人数少的军队一样，关键在于要组织编制好。要做到指挥人数多的军队作战，如同指挥人数少的军队作战一样，关键在于用旌旗金鼓发布信号来指挥进攻与后退。全国军队如此之多，一旦遇到敌人的进攻，而要使其保持不败，就需要将"奇兵"和"正兵"战术运用得恰到好处。军队进攻所到之处，如同以石击卵一样所向无敌，这就需要采取"避实就虚"战术。

① 兵势篇：论军事上的优势。
② 分数：分、数指军队之组织、编制。编制严密，人多人少均同样指挥。
③ 斗：指挥（军队）。
④ 形名：指旌旗和金鼓。士卒望旌旗、听金鼓而行动，人数多少均不乱。
⑤ 奇正：古代作战以对阵交锋为正，以埋伏、掩袭等为奇。
⑥ 碫：磨刀石。
⑦ 虚实：有备为实，无备为虚。以实击虚，如石击卵。

Potential

Sunzi said: Managing a big army is in principle the same as managing a small one: it is a matter of organization. Directing a large army is the same as directing a small troop: it is a matter of strict and impartial command. What makes the whole army under attack not suffer defeat is a matter of adopting normal and special tactics. Troops thrown against the enemy like a grindstone against an egg is a matter of staying clear of the enemy's main forces and striking at his weak points.

(二)

凡战者，以正合①，以奇胜。故善出奇者，无穷如天地②，不竭如江河。终而复始，日月是也。死而更生③，四时是也。声不过五④，五声之变，不可胜听也⑤；色不过五⑥，五色之变，不可胜观也；味不过五⑦，五味之变，不可胜尝也。

战势不过奇正，奇正之变，不可胜穷也。奇正相生⑧，如循环之无端。孰能穷之？

◇ 白话译文

大凡作战，一般都是以"正兵"抵挡敌人，用"奇兵"夺取胜利。所以，善于出奇制胜的将帅，他的战术方法就像天地那样变化无穷，像江河那样奔流不息。周而复始，如同日月的运行一样从不间断；循环往复，就像四季的交替那样不停更迭。乐音只不过有宫、商、角、徵、羽五个音阶，然而这五个音的变化排列，却会产生出千变万化令人百听不厌的乐曲。颜色只不过红、黄、蓝、白、黑五种基本色素，可是这五种色彩变化调配，就会产生绚烂无比令人赏心悦目的色彩。味道只不过酸、甜、苦、辣、咸五种，但是这五种味道混合变化，却可以制造出千滋百味。作战的形式不过"奇"和"正"两种，可是，两者的组合变化，却是不可穷尽的。"奇"和"正"的相互转化，就像顺着圆环旋转一样，无头无尾，无始无终，谁能穷尽它呢？

① 以正合：以正兵作战。合，交战。
② 无穷如天地：指以奇取胜，可变化无穷。
③ 死而复生：指四时更替。
④ 声不过五：指宫、商、角、徵、羽五声。
⑤ 不可胜听也：听之不尽。
⑥ 色不过五：指红、黄、蓝、白、黑五色。
⑦ 味不过五：指酸、咸、辣、苦、甜五味。
⑧ 奇正相生：奇正会相互转化。

During a war, the general should adopt the normal way of confronting the enemy, while using special tactics to take the enemy by surprise. He who is adept in such tactics can apply them in ways as infinite as heaven and earth and as the never-ending flow of rivers. They terminate, but soon begin again, like the sun and moon in motion; they die away, but then they regenerate like the seasons in sequence. There are only five musical notes, but their varied combinations bring about melodies more pleasing and wonderful than ever heard. There are only five basic colors, but their variations and blending produce colors more beautiful and splendid than ever seen. There are only five cardinal tastes, but their mixture yields flavors more delicious and savory than ever tasted[1].

Similarly military formations are not more than the application of special and normal tactics, but their variations and combinations will give rise to an infinite series of maneuvers. Both special and normal tactics are interdependent and mutually reproductive like a cyclical movement that has neither a beginning nor an end. Who can know its infinitude?

[1] In ancient China, the people considered that there were five musical notes, namely: *gong*, *shang*, *jue*, *zhi* and *yu*; five basic colors, namely: blue, yellow, red, white and black; and five cardinal tastes, namely: sour, salty, pungent, bitter and sweet.

(三)

激水之疾,至于漂石者,势也;鸷鸟①之疾,至于毁折者,节②也。

故善战者,其势险,其节短。势如彍弩③,节如发机④。

◇ 白话译文

湍急的水流以飞快的速度奔泻,以致能把石头冲走,水冲击的强大力量就叫作势。凶猛的飞鸟,以飞快的速度俯冲,以致能搏杀鸟雀,这就是节奏有力速度迅猛的缘故。

所以,善于指挥作战的人,所造成的态势是险峻的,出击时的节奏是短促有力、锐不可当的。险峻的态势就像张满的弓弩,短促的节奏如同触动弓弩把箭矢突然射出一样。

(四)

纷纷纭纭,斗乱⑤而不可乱也;浑浑沌沌,形圆而不可败也⑥。

◇ 白话译文

战旗纷纷飘扬,人马纷纭混杂,虽然战斗很激烈,也必须使自己的部队不发生混乱。在浑浑沌沌的情况下打仗,必须把队伍排成圆阵,首尾连贯使敌人无隙可乘。

① 鸷鸟:一种凶猛的鹰隼。
② 节:节奏,指在短距离之内以俯冲之势伤杀猎物。
③ 彍(guō)弩:张满弩机。
④ 发机:触发扳机。
⑤ 斗乱:于纷乱状态中指挥战斗。
⑥ 形圆而不可败也:圆阵不见首尾,扰而不乱,就不会失败。

A torrent that flows swiftly can float heavy boulders. It is because of the strong momentum of the water. A hawk that flies as quickly as it strikes can destroy its prey. It is because of the timeliness and speediness of its strike.

Similarly, a general who is skilled in war can exploit his own vantage position and launch a swift and sharp attack. His potential is like a crossbow that is fully drawn, and his swiftness is like a shaft that is shot off.

In the tumult of battle, your army should stay calm. In the chaos of war, where there is no sense of direction, your men should appear to be milling about in circles but remain invulnerable.

(五)

乱生于治,怯生于勇,弱生于强①。治乱,数也②;勇怯,势也③;强弱,形也④。

◇ 白话译文

在一定条件下,"乱"可以由"治"产生,"怯"可以由"勇"产生,"弱"可以由"强"产生。"治乱"是组织指挥的问题;"勇怯"是破敌之势的问题;"强弱"是军事实力的问题。

(六)

故善动敌者,形之,敌必从之⑤;予之,敌必取之⑥。以利动之,以卒待之⑦。

◇ 白话译文

所以,善于调动敌人的将帅,要伪装造成假象迷惑敌人,敌人必定会为其所骗;给敌人东西(如物资、用品),引诱敌人前来夺取;用小利去引诱调动敌人,以自己预先布置的兵力趁机袭击敌人。

① 此句指乱治、怯勇、弱强可以转化。彊,即"强"。
② 治乱,数也:治、乱决定于组织编制是否健全。
③ 勇怯,势也:勇、怯决定于是否得势。
④ 强弱,形也:强、弱决定于实力。
⑤ 形之,敌必从之:以伪装诱敌,使其中计。
⑥ 予之,敌必取之:以小利诱敌,使其上钩。
⑦ 以卒待之:伏兵待敌。

Disorder comes from order, cowardice stems from courage, and weakness is born of strength. Order or disorder depends on organization, courage or cowardice on circumstances, strength or weakness on dispositions.

Therefore, he who is adept at moving the enemy about can put on a deceitful appearance, according to which the enemy will act. He can lure the enemy with something profitable, which the enemy is certain to take. He can drive the enemy about with small advantages and await the enemy in strength.

（七）

故善战者，求之于势，不责于人，故能择人而任势①。

任势者，其战人②也，如转木石。木石之性，安则静，危则动，方则止，圆则行。

故善战人之势，如转圆石于千仞之山者，势也。

◇ 白话译文

所以善于指挥打仗的将帅，会把注意力放在"势"上，而不是动不动就责备苛求下属，反倒能选择合适的人才，造出于己有利的态势。

善于"任势"的指挥官，在指挥将士作战的时候，就像转动木头和石块一样轻松自如。木头和石块的特性是放在安稳平坦的地方就比较稳定，而放在陡峭倾斜的地方就容易滚动，方形的木石一般比较稳定，圆形的最容易翻滚。

所以善于指挥作战的人在作战中能造就对自己有利的情形，就如同一块圆形的石头从几千尺的高山上滚下来那样势不可当，这就是军事上所谓的"势"！

① 择人而任势：善用人及善于利用形势。
② 战人：指挥士兵作战。

The general who is skilled in war always capitalizes on the situation of war and never makes excessive demand on his subordinates. Therefore such a general can select the right men and fully exploit the favorable situation. He who is skilled in exploiting the situation directs his men in battles like rolling logs or rocks. The nature of logs or rocks is that they will remain unmoved if the ground is flat; they will roll forward if the ground is slanting; if they are square, they will stop there; if they are round, they will roll forward.

Thus, the force of the skillful general is just like the momentum of a round rock rolling down a mountain of ten thousand feet high. This is the meaning of potential.

虚实篇

（一）

孙子曰：凡先处战地而待敌者佚①，后处战地而趋战②者劳。故善战者，致人而不致于人③。

能使敌人自至者，利之也④。能使敌人不得至者，害之也⑤。故敌佚能劳之，饱能饥之，安能动之。

◎ **白话译文**

孙子说，凡是先占据战场等待敌人到来的就从容、主动，而后到达战场的难免仓促应战，疲于奔命，处处被动。所以，善于指挥作战的人，总是设法调动敌人而自己不为敌人所动。

使敌人主动上钩，就要用小利小惠去引诱他；敌人不能到达预定区域，就要制造困难和险境去阻止他。因此，敌人休息的时候，就想方设法干扰他，让他疲劳；敌人粮草给养充分，要想办法夺取他们的粮食，使他们饥饿；敌人若是安营扎寨、固守不动的时候，就要想办法调动他，让他们立不住脚跟。

① 佚：同"逸"。
② 趋战：奔赴作战。
③ 致人而不致于人：调动别人而不被人调动。
④ 利之也：以利引诱。
⑤ 害之也：设法妨害、阻挠。

Weakness and Strength

Sunzi said: He who occupies the battlefield first and awaits the enemy will be at ease; he who arrives later and makes war in haste will be weary. Thus, he who is skilled in war always leads the enemy by the nose, and will not be manipulated by the enemy.

Give the enemy inducement and you can make him come into your trap. Threaten him with danger and you can stop him from approaching you. Therefore, the general should tire the enemy while he is at ease, starve the enemy while he is well fed, and make the enemy move while he is stationary.

（二）

出其所不趋①，趋其所不意。行千里而不劳者，行于无人之地也。

攻而必取者，攻其所不守也。守而必固者，守其所不攻也。

故善攻者，敌不知其所守；善守者，敌不知其所攻。微乎微乎，至于无形②；神乎神乎，至于无声③，故能为敌之司命④。

◇ 白话译文

在敌人无法紧急救援的地方出击，向敌人意想不到的方向进攻。部队行军千里而不疲劳，是因为走在没有敌人阻碍或是防守不严的地区。

进攻必然能得手，是因为攻击的是敌人的防守漏洞或是很难守住的地方。防御能够固若金汤，是因为防守着敌人不敢进攻或是攻不破的地方。

所以说，善于进攻的将帅，让敌人不知道自己该守什么地方才好；而善于防守的将帅，让敌人更是无从下手，不知道从哪里进攻。实在是太微妙了，微妙到看不到任何踪迹形影。也实在是太神奇了，神奇到听不见一丝声音讯息。这样敌人就对我们的任何行动都无法识破，被弄得莫名其妙，所以我们才能够顺利调动敌人，成为敌人命运的主宰。

① 出其所不趋：出击敌方无法救援之处。
② 微乎微乎，至于无形：微妙莫测，不见形迹。
③ 神乎神乎，至于无声：神奇而不漏风声。
④ 司命：主宰。

Appear at the place to which the enemy won't come; attack a place where the enemy does not expect you. If you can lead your troops to march a thousand *li* without fatigue, it is because you march in the area where the enemy has not set up defences.

That you are certain to take what you attack is because the enemy cannot fortify it. That you are certain of success in holding what you defend is because the enemy cannot attack it.

So with those who are adept in attack, the enemy does not know where and how to defend; and with those who are adept in defence, the enemy does not know where and how to attack. Be extremely subtle, so subtle that no one can find any trace; be extremely mysterious, so mysterious that no one can hear any information. If one can do so, he can hold the enemy's fate in his hands.

(三)

进而不可御者,冲其虚也;退而不可追者,速而不可及也。故我欲战,敌虽高垒深沟,不得不与我战者,攻其所必救也。我不欲战,画地而守之①,敌不得与我战者,乖其所之也②。

◇ 白话译文

进攻而使敌人无法抵御,是因为冲击了敌人防守薄弱的地方;退却而使敌人无法追及,是因为迅速而使他来不及追赶。所以,我军想要攻打的时候,敌人即使有深沟高垒坚守,也不得不出来同我军打仗,是因为进攻的地方是敌军必须救援的要害之处。我军不想打仗的时候,即使只在地上画道线,敌人也无法攻进来,是因为设法调动他,使他背离了所要进攻的方向。

① 画地而守之:画地为营,虽无甚设防,敌人亦不敢进攻。
② 乖其所之也:(皆因)引敌往别处。乖,违背、改变。

The offensive one takes can be so strong that the enemy cannot defend just because one strikes at the enemy's weak point. One can withdraw without being overtaken by the enemy just because one moves so swiftly that the enemy cannot pursue. If we intend to fight, the enemy, though holding fast to his position with ramparts high and ditches deep, is compelled to fight with us because we attack where he must succor. If we do not intend to fight with him, even though we set up little defence, the enemy will not intrude upon us because we divert him from going where he wishes.

（四）

故形人而我无形①，则我专而敌分。我专为一，敌分为十，是以十攻其一也，则我众而敌寡。能以众击寡者，则吾之所与战者约矣②。

吾所与战之地不可知③。不可知，则敌所备者多。敌所备者多，则吾所与战者寡矣。

◇ 白话译文

因此，能查明敌人的情况而使敌人无法查明我军的情况，我军的兵力就可以集中起来，而敌人的兵力就不得不分散。我军兵力集中在一起，敌人兵力分散在十处，这就表示可以用十倍于敌的兵力去打击敌人，造成敌寡我众的有利形势。战争中如果以众击寡的话，那么同我军正面作战的敌人就变得少多了。

我军所要进攻的地方，敌人无法得知，不得而知的话，他就要加强防备，敌人防备的地方越多，兵力也就越分散，这样，我军所直接攻击的敌人就减少了。

① 故形人而我无形：查明敌人形迹而自己隐蔽。
② 则吾之所与战者约矣：则我方面对的敌人少而弱。
③ 吾所与战之地不可知：我方所选与敌交战之处对方不知。

If we expose the enemy's disposition and hide ours, we can concentrate our troops and divide the enemy's forces. If we concentrate our forces at one place while the enemy disperses his forces at ten places, then we are ten to one when we launch an attack on him at one place, which means our forces are numerically superior. If we are able to use many to strike a few, naturally it will be easy enough for us to deal with, because the enemy there is small and weak.

The spot our forces intend to attack must not be known to the enemy. In this way, he must take precautions at many places against our attack because he does not understand where we shall strike; when he takes precautions at many places, his troops at any given spot will be fewer.

（五）

故备前则后寡，备后则前寡，备左则右寡，备右则左寡。无所不备，则无所不寡。寡者，备人者也①；众者，使人备己者也②。

◇ 白话译文

这种情况下很容易顾此失彼，防备了前面，后面的兵力就薄弱了；防备了后面，前面的兵力就薄弱了；注意防备左翼，右翼的兵力就薄弱一些；注意防备右翼，左翼就变得薄弱了；处处防备，就整体薄弱。造成兵力薄弱的原因是处处设防，而只要能够集中优势兵力，则可以迫使敌人处处防备我军。

① 寡者，备人者也：兵力之所以弱，在于分兵以防对方。
② 众者，使人备己者也：兵力强则因能迫使对方分兵把守。

If the enemy takes precautions in the front, his rear will be weak; if he takes precautions in the rear, his front will be fragile; if his left gets strengthened, his right will be weakened; if his right is well prepared, his left will be easily destroyed; if he strengthens everywhere, he will be weak everywhere. One who has few must take precautions against possible attacks everywhere; one who has many compels the enemy to prepare against his attacks.

(六)

故知战之地,知战之日,则可千里而会战;不知战地,不知战日,则左不能救右,右不能救左,前不能救后,后不能救前,而况远者数十里,近者数里乎?

以吾度①之,越人②之兵虽多,亦奚益③于胜败哉?

故曰:胜可为也。敌虽众,可使无斗④。

◈ 白话译文

所以能够预知同敌人交战的地点和交战的时间,那么即使相距千里也可以同敌人交战。而不能预知在什么地方打仗,在什么时间交火,那就左翼不能救右翼,右翼也不能救左翼,前面不能救后面,后面也不能救前面,何况军队远的相隔几十里,近的也有好几里呢?

据我分析,越国的军队虽然多,但是对于决定战争的胜负是没有什么好处的。

所以说,胜利是完全凭争取得来的。敌人兵力虽多,但可以用计使其无法使出全部力量同我军交战。

① 度(duó):推断。
② 越人:越国人。春秋时期,吴越两国长期交战,孙子助吴。故常以越指敌对一方。此处泛指敌方。
③ 奚益:何能有益于。
④ 无斗:无法与我军战斗。

If a general knows both the place and time of a battle to come, he can lead his troops to go even a thousand *li* away for a decisive battle. If he knows neither the place nor the time of a battle to come, then his left wing cannot help his right, and his right wing cannot save his left; the troop in the front cannot turn back to help the rear, and the rear cannot go forward to relieve the front, let alone looking after the more distant portions of the troops tens of *li* apart and even the nearest several *li* away.

My opinion is that the troops of the State of Yue[1] are many, but from the above-mentioned principle, can you say for sure that it will help the State of Yue win a battle?

So a victory may be made. Even if the enemy's troops are many, we can find a way to make them unable to fight.

[1] The State of Yue: Wu and Yue were two states in ancient China, Sunzi himself helped Wu against Yue.

（七）

故策之而知得失之计①，作之而知动静之理②，形之而知死生之地③，角之而知有余不足之处④。

故形兵⑤之极，至于无形。无形，则深间⑥不能窥，智者不能谋。因形而错胜于众⑦，众不能知；人皆知我所以胜之形，而莫知吾所以制胜之形。故其战胜不复⑧，而应形于无穷⑨。

◇ 白话译文

分析研究双方的情况，可以得知双方所处条件的优劣得失；小范围地骚扰敌人，从其反应可以了解敌人出兵布阵的规律；侦察情况，可以了解战地各处是否利于攻守进退；用小股兵力试探性地进攻敌人，可以进一步了解敌人兵力的虚实强弱。

用假象迷惑敌人的用兵方法运用到出神入化的程度，完全可以不露出一点儿行迹，使敌人无法判断形势，那么，即使隐藏得很深的间谍也无法探明我方的虚实，再聪明的敌人也想不出对付我军的办法。把根据敌情变化灵活地运用战术而取得的胜利摆在众人面前，人们也看不出所以然来，因为人们只知道我用来战胜敌人的方法，但是不知道我是怎样根据敌情的变化灵活运用这些战法，从而出奇制胜的。所以，我取胜的谋略方法几乎不重复，而是适应不同的情况而变幻无穷。

① 策之而知得失之计：策度、分析可知敌情之优劣得失。
② 作之而知动静之理：小范围地骚扰敌人，从其反应弄清敌方行动规律。
③ 形之而知死生之地：以伪装阵形诱惑敌人，以探知对方生死要害。
④ 角之而知有余不足之处：角量试探敌人实力以判断敌人优劣所在。
⑤ 形兵：伪装阵形诱敌。
⑥ 深间：深藏的间谍。
⑦ 错胜于众：将胜利置于人之前。错，同"措"，放置。
⑧ 不复：不重复。
⑨ 而应形于无穷：适应情况而变化无穷。

If you consider and analyze the enemy's situation and his plan to battle, you can have a clear understanding of his chances of success. If you agitate the enemy, you can know the patterns of his attack and defence. If you lure the enemy, you can find out his vulnerable points. If you count up the number of the enemy's soldiers and horses, you can know his strengths and inadequacies.

Accordingly, the highest of the military art of deceiving the enemy is to conceal your dispositions. In this way, the most penetrating spies of the enemy cannot pry in, even the wise man may not conspire against you. Even if you make public that you have won victory by taking appropriate tactics in conformity to the enemy's changing situation, they are still unable to comprehend it. Though everyone knows the tactics by which you have won victory, they are unable to know how it was applied to defeat the enemy. Therefore, the way to defeat the enemy should not follow the beaten track, but change constantly according to the enemy's changing situation.

（八）

夫兵形①象水，水之形，避高而趋下；兵之形，避实而击虚。水因地而制流②，兵因敌而制胜。

故兵无常势，水无常形；能因敌变化而取胜者，谓之神。故五行③无常胜，四时无常位④，日有短长，月有死生⑤。

◎ 白话译文

用兵作战的规律像水，水流动的规律是避开高处而向下奔流；用兵的规律则是避开敌人坚实的地方而攻击敌人薄弱的地方。水根据地形的变化而选择奔流的方向，用兵则要依据敌情的变化而制定不同的作战策略。

所以说，作战没有固定的方式方法，就像水流没有固定的形状一样，能够根据敌情的发展变化而采取灵活的措施取胜的人，才可以称得上是用兵如神。用兵的规律就像自然现象一样，五行相生相克，四季循环往复，昼夜因季节的变化而有长有短，月亮因自身的变化而有圆有缺。

① 兵形：用兵之方式、规律。
② 制流：制约流向。
③ 五行：金、木、水、火、土为五行。中国古代认为五行相生相克，均不能独胜。
④ 四时无常位：春、夏、秋、冬四季更替，永无休止，均不能常在。
⑤ 月有死生：指月有盈亏圆缺。

Military tactics are like flowing water. Flowing water always moves from high to low, and military tactics always avoid the enemy's strong points and attack his weak points. Whereas the course of flowing water is decided by different landforms, the way to win victory in a battle is decided by altering the tactics according to enemy's changing situation.

Accordingly, the way to fight never remains constant and water never flows in the same way. Whoever can win victory by taking appropriate tactics according to the enemy's different situations is one who directs military operations with great skill. It is just like *Wuxing*[①] (the Five Elements), of which none is forever dominant; and the four seasons, of which none can last forever; and the days, which are sometimes long and sometimes short; and the moon, which sometimes waxes and sometimes wanes.

[①] *Wuxing*: Classic Chinese philosophy calls Metal, Wood, Water, Fire and Earth the five elements. The Five Elements represent five states of forces of expansion or condensation.

军争①篇

（一）

孙子曰：凡用兵之法，将受命于君，合军聚众，交和而舍②，莫难于军争。

军争之难者，以迂为直③，以患为利④。故迂其途，而诱之以利，后人发，先人至⑤，此知迂直之计者也。

◇ 白话译文

孙子说：根据一般的战争规律，统帅受命于国君，从组织人民群众编成军队，到开赴前线与敌对阵，在这过程中，没有比抢先争取到有利时机、有利地势更困难的了。

抢先争取有利时机之所以很困难，是因为要把遥远的弯路变成直道，要把不利条件化为有利条件。因此故意迂回绕道，用小利引诱敌人，这样就能比敌人晚出发却能在敌人之前到达战略要地，懂得这样做的人，就是懂得变迂为直谋略的人。

① 军争：两军抢先争夺制胜条件。
② 交和而舍：和，指和门，即军门。舍，驻扎。意为两军对垒。
③ 以迂为直：变迂曲为近直。
④ 以患为利：化患害为有利。
⑤ 后人发，先人至：比敌人晚出发，先到达。

Fighting for Military Advantage

Sunzi said: In military operations the general receives his commands from the sovereign, then he assembles soldiers to form units, and mobilizes them to confront the enemy. During the whole process nothing is more difficult than to fight for a favorable position with the enemy.

The reason why it is most difficult is that the general must make a circuitous route direct and turn disadvantage into advantage. He can deceive the enemy by taking a devious route and tempt the enemy with a bait, so that his own troops arrive at the battle ground earlier, though they set out later than the enemy. Only by doing this can he know the artifice of "making a circuitous route direct".

（二）

故军争为利，军争为①危。举军而争利，则不及；委军②而争利，则辎重捐③。

是故卷甲④而趋，日夜不处，倍道兼行，百里而争利，则擒三将军⑤，劲者先，疲者后⑥，其法十一而至⑦。五十里而争利，则蹶上将军⑧，其法半至。三十里而争利，则三分之二至。

是故军无辎重则亡，无粮食则亡，无委积⑨则亡。

◇ 白话译文

所以军争有有利的一面，同时也有危险的一面。假如全军带着全副装备和辎重去抢占有利的时机，那么行军肯定会迟缓；如果放下笨重的装备去抢占先机，那么辎重就要被抛弃掉，这又是一大损失。

因此，假如卷起盔甲、轻装急进，昼夜不停，加倍行程赶路，路上可能就会遇到意外情况：走百里的路程去抢占先机，三军的将帅都有可能被俘。身体强壮的战士先到，体弱疲惫的士卒掉了队，其结果是只会有十分之一的兵力赶到；走五十里去抢占先机，先头部队的将领就会受挫折，队伍只有半数兵力能够赶到预定地点；走三十里去抢占先机，可能只有三分之二的兵力赶到。

因此，军队没有辎重就不能投入战斗，没有粮食就不能生存，没有物资就不能取胜。

① 为：有。全句为：军争有利亦有险。
② 委军：丢弃军队物资装备。
③ 捐：损失。
④ 卷甲：披铠甲。
⑤ 则擒三将军：结果上中下三军将领均为敌俘。
⑥ 疲者后：疲弱者掉队。
⑦ 十一而至：只有十分之一士卒能到达。
⑧ 蹶上将军：先行将领会受挫。
⑨ 委积：物资储备。

There is not only advantage but also danger in fighting for a favorable position. If you strive for a favorable position in battle, bringing along the whole impedimenta, naturally, you will be slowed down. If you leave the impedimenta behind, naturally, it will be lost.

So if your army buckles on armor and hastily makes for a favorable position in battle, stopping neither day nor night and marching at double speed, as a result, after running a hundred *li*, the main generals of the army will be captured; those who are strong and vigorous will get there first, those who are feeble and tired will struggle behind. In this way, only one-tenth of the army will arrive on time. If they run fifty *li* to pursue a favorable position, the general of the vanguards will suffer setbacks, and only half of the army will arrive there on time. If they run thirty *li* to fight for a good position, only two-thirds will arrive.

Everyone knows that an army will be defeated by the enemy if it has no impedimenta, food and military provisions.

(三)

　　故不知诸侯之谋者,不能豫交①;不知山林、险阻、沮泽②之形者,不能行军;不用乡导③者,不能得地利。

◎ 白话译文

　　所以,不了解列国诸侯谋略,不能与其结交;不熟悉山岭、森林、险要、阻塞、湖沼等行军途中地理情况,不能率军行进;不重用向导,就不能有效地利用有利的地形。

① 豫交:预先结交。豫,同"预"。
② 沮泽:水草丛生之沼泽地带。
③ 乡导:向导。

A commander who does not understand the plots and schemes of the princes cannot enter into alliances with them. He who is not familiar with different topographical features of mountains and forests, hazardous defiles, marshes and swamps cannot conduct the march of an army. He who does not hire local guides cannot gain a favorable position for battle.

(四)

故兵以诈立①,以利动,以分合为变者也。故其疾如风,其徐如林,侵掠如火,不动如山,难知如阴②,动如雷震;掠乡分众③,廓地分利④,悬权⑤而动。先知迂直之计者胜。此军争之法也。

◎ 白话译文

用兵打仗要懂得利用诡诈多变来获得成功,根据是否有利采取行动,分散或集中使用兵力,随情况而变。所以部队行动迅速时犹如迅猛的狂风;行动舒缓时犹如严整的森林;进攻敌人时犹如烈火焚烧;防御时像山岳一样岿然不动;隐蔽时像阴天看不见的日月星辰那样,发起进攻犹如迅雷猛击。夺取敌"乡"的粮食、资财,要分兵数路;开拓疆土,取得敌国丰富的资源,要分守要地,衡量利害得失,然后相机行动。事先懂得以迂为直方法的就会胜利,这是争取先制之利的原则。

① 以诈立:以诈取胜。
② 难知如阴:隐蔽难测。
③ 掠乡分众:分兵掠夺城邑(另一种解释是:掠来财物给军队)。
④ 廓地分利:开拓疆土,分守利害(另一种解释是:分与有功者)。
⑤ 悬权:秤锤悬秤杆上。在此指衡量。

In military operations, you may gain victory with military stratagem, you should take action when conditions are favorable, and you may divide or concentrate the army according to circumstances. So you should be as swirl as strong wind while taking action; you should be as stable as silent forests which the wind cannot shake while you move slowly; you should be as fierce and violent as raging flames while raiding the enemy's state; you should be as firm as high mountains while being stationed there; you should be as inscrutable as something behind the clouds, and you should strike as suddenly as thunderclap. You must divide your forces and plunder the enemy's countryside, and separate them for the defence of the newly captured territory. You must weigh the pros and cons before you move. He who masters the tactic of deviation first will win victory. This is how to fight for military advantage.

（五）

《军政》^①曰："言不相闻，故为金鼓；视不相见，故为旌旗。"

夫金鼓旌旗者，所以一人^②之耳目也。

人既专一，则勇者不得独进，怯者不得独退，此用众^③之法也。

故夜战多火鼓，昼战多旌旗，所以变人之耳目也。

◇ 白话译文

《军政》上说："作战中用语言指挥听不到，所以设置金鼓；用动作指挥看不见，所以设置旌旗。"

金鼓、旌旗是统一全军行动的标志。

战士的视听既然整齐如一，那么，勇猛的战士就不能单独前进，怯懦的战士也不能单独后退。这就是指挥大部队作战的方法。

所以夜晚交战多用火光和鼓声，白天作战多用旌旗，之所以变换这些信号，都是为了适应士卒的视听能力。

① 《军政》：古代兵书。
② 一人：统一士卒。
③ 用众：指挥大部队。

The book *Military Management* says, "Gongs and drums are used in battle because voices are not heard; banners and flags are used because soldiers cannot see one another clearly."

Accordingly, they usually use gongs, drums, flags and banners as instruments to unify the army.

When the soldiers have been unified, the courageous cannot advance alone, and the cowardly cannot retreat by himself. This is the rule for directing a large army.

So fires and drums are usually used as signals in night battles, while banners and flags are employed in day battles. What it does is just to adapt to the soldiers' ability to hear and to see.

(六)

故三军可夺气①,将军可夺心②。是故朝气锐,昼气惰,暮气归。

◇ 白话译文

对于敌人的军队,可以挫伤它的士气,对于敌人的将领,可以动摇他的决心。军队初战的时候,士气比较旺盛,经过一段时间之后,就逐渐怠惰,到了后期,士卒就会气竭思归。

① 夺气:挫败锐气。
② 将军可夺心:动摇敌将之心。

You should deflate the enemy's fighting spirit and shake the general's morale. Normally, at the beginning of war the spirit of the enemy is keen and irresistible. A certain period later, it will decline and slacken. In the final stages of war, it will become feeble, and the soldiers are in no mood to fight.

（七）

故善用兵者，避其锐气，击其惰归，此治气①者也。以治待乱，以静待哗，此治心②者也。以近待远，以佚待劳，以饱待饥，此治力③者也。

无邀④正正之旗，勿击堂堂之陈⑤，此治变⑥者也。

◇ **白话译文**

所以善于用兵的人，总是避开敌人的锐气，等到敌人松懈疲惫时才去打它，这是掌握军队士气的方法。以我军的严整来对待敌人的混乱，以我军的镇静来对待敌人的骚动不安，这就是从心理上制伏、战胜敌人的办法。先靠近战场来等待长途跋涉来袭的敌军，用休整良好的部队来对待疲劳困顿的敌人，用粮足食饱的部队来对待粮尽人饥的敌人，这就是从体力上制伏、战胜敌人的办法。

不去迎击旗帜整齐、部署周密的敌人，不去攻击阵容严整、实力雄厚的敌军，这是正确掌握随机应变的方法。

① 治气：掌握军队士气之规律。
② 治心：掌握军心之方法。
③ 治力：掌握军力之要领。
④ 邀：迎击。
⑤ 陈：同"阵"。
⑥ 治变：掌握随机应变的方法。

The skillful commander always avoids the enemy when his morale is high and irresistible, and attacks him when he is slack, tired and reluctant to fight. If he does so he can master the soldiers' morale. He keeps a highly disciplined army to fight the confused enemy army, and confronts the clamorous enemy troops with his own troops in serenity. If he does so, he can have a good grasp of the soldiers' morale. He takes his troops close to the battlefield to wait for the enemy still coming from afar, leads his troops that has had a full rest against the exhausted enemy, and brings his well-fed troops upon the enemy soldiers that are hungry. If he does this, he has good control of military strength.

The skillful commander never meets a head-on enemy that lines up in good order with banners high, nor attacks an enemy with battle formation strong and impressive. This shows that he has a clear understanding of the flexible use of tactics.

（八）

故用兵之法：高陵勿向，背丘勿逆①，佯北勿从，锐卒勿攻，饵兵勿食，归师勿遏，围师必阙②，穷寇勿迫。此用兵之法也。

◎ 白话译文

所以，用兵的法则是：敌人占领高地，不要去仰攻；敌人背靠高地，不要从正面攻击；敌人假装败退，不要跟踪追击；敌军锐气正盛，不要去进攻；敌人以"饵兵"诱我，不要去理睬；正在撤退回国的敌人，不要去拦阻；包围敌人，要留个缺口；对陷入绝境的敌人，不要逼迫太甚。这些，都是用兵应当掌握的原则。

① 背丘勿逆：敌人背倚丘陵，不宜逆攻之。
② 围师必阙：围敌三面，留一缺口，使有生路而不死战，此乃攻心之术。

Here are some principles of military operations.

Never launch an upward attack on the enemy who occupies high ground; nor meet the enemy head-on when there are hills backing him; nor follow on his heels in hot pursuit when he pretends to flee; nor attack troops that are fresh and strong. Never swallow a bait offered by the enemy, nor thwart the enemy that withdraws from the front. To a surrounded enemy you should leave a way for his escape, and do not press too hard the enemy that is in a desperate corner. Such are the ways of military operations.

九变① 篇

（一）

孙子曰：凡用兵之法，将受命于君，合军聚众。圮地无舍②，衢地交合③，绝地无留，围地则谋④，死地则战。涂有所不由⑤，军有所不击，城有所不攻，地有所不争，君命有所不受。

◇ **白话译文**

孙子说：一般用兵的法则是，主将要服从国君的命令，动员征集组织民众，然后编成军队。军队出征时，途经山岭、森林、险要、阻塞、水滩、湖沼等难于通行的地区时，不要安营扎寨；处在几国交界、四通八达的地理位置时，应该广泛结交诸侯，建立友好的外交关系；在没有水源、无法保证军需供应的地方千万不可停留；行军遇到容易设伏兵的地方时，就要巧妙设计能够突围；而陷入不拼命就会死亡的地方时，就要把生死置之度外，奋战到底。有的道路按正常情况可以走，但是偏偏不走，以期出敌不意，令敌方计划落空；有的敌军可以打败他，但暂时不要打败他；有的城堡虽然可以攻取，但是不要马上攻取它；有的地方可以争夺到，但先不要急着去争夺；国君的命令有的可以接受，有的可以不接受。

① 九变：九为极数，九变指极其机动灵活的作战方法。
② 圮地无舍：山林、险阻、沮泽难行之道，不可屯兵驻留。
③ 衢地交合：于四通八达之地，要广交诸侯以求互助合作。
④ 围地则谋：于四周险阻地带，要出奇谋，以免被袭。
⑤ 涂有所不由：涂，通"途"。由，通过。即有些道途不要通过。

Tactical Variables

Sunzi said: In military operations, the general receives his commands from the sovereign, then he assembles soldiers to form units. In leading his troops, do not encamp or station where it is difficult for the army to pass through; ally with the local princes where the highway extends in all directions; do not linger where it is uninhabitable; venture into an enclosed region with shrewdness and stratagem; fight a desperate battle where there is no way to advance or retreat. There are some roads which should not be followed; and some enemy troops which should not be attacked. There are some cities which should not be captured, some territories which should not be seized, and some orders from the sovereign which need not be obeyed.

（二）

故将通于九变之利者，知用兵矣；将不通于九变之利者，虽知地形，不能得地之利矣。治兵不知九变之术，虽知五利①，不能得人之用矣。

◈ 白话译文

将帅能够精通以上各种灵活机变的战术，就算得上是懂得用兵了。反之，如果将帅不懂得上面这些灵活机变用兵的好处，即使了解地形，也不能从有利的地形中占到便宜。指挥军队不知道各种机变的方法，虽然简单粗浅地了解了以上五种方法，也不能充分发挥军队的战斗力。

① 五利：指"涂有所不由，军有所不击，城有所不攻，地有所不争，君命有所不受"。

All the above are the tactical variables which a general or commander should thoroughly understand. Only if he knows them well can he know military operations. If he does not have a clear understanding of their real values, he cannot use a territory to his advantage though he is well acquainted with its topography. If a general does not know the tactical variables, he will not be able to bring the soldiers' fighting capacity into play, in spite of his knowing the five advantages[1].

[1] Five advantages: "There are some roads which should not be followed; ... and some orders from the sovereign which need not be obeyed." (see p.103)

（三）

是故智者之虑，必杂于利害①。杂于利而务可信也②，杂于害而患可解也。

是故屈诸侯者以害，役诸侯者以业，趋诸侯者以利③。

◈ 白话译文

所以说，聪明的将帅考虑问题，一定会兼顾利与害两个方面。在不利的条件下看到有利的一面，事情就可以顺利进行；有利的条件下看到不利的因素，祸患便可及早解除。

所以要使诸侯屈服，就用诸侯最害怕的事情去威胁他们；要役使诸侯，就用危险的事情去困扰他们；要使诸侯归附，就用利益去引诱他们。

（四）

故用兵之法，无恃其不来，恃吾有以待也④；无恃其不攻，恃吾有所不可攻也。

◈ 白话译文

所以用兵，不要寄希望于敌人不来打，而要依靠自己严阵以待，充分准备；不要寄希望于敌人不来进攻，而要依靠自己有使敌人无法攻破的充足力量和办法。

① 杂于利害：充分考虑利害两方。
② 而务可信也：指有信心完成任务。
③ 趋诸侯者以利：动以小利，使诸侯趋之。
④ 无恃其不来，恃吾有以待也：不要寄希望于敌人不来，而要靠自己有充分准备。

A wise general must give his consideration to both favorable factors and unfavorable factors. He should take full account of the unfavorable factors when he finds himself in a favorable position. Only then can he succeed in his plans. He should take full account of the favorable conditions while in an unfavorable position. Only then can he resolve the difficulties.

If you want to subdue the hostile princes, threaten them with what they fear most; if you want to make them do what you desire, trouble them with busy work; if you want to lead the enemy by the nose, give them small advantages.

In military operations, the following is a useful rule. Never rely on the likelihood of the enemy's not coming, but on your own readiness to meet them. Do not expect that the enemy may not launch an attack, but count on the fact that you have made yourself invincible.

(五)

故将有五危：必死，可杀也①；必生，可虏也②；忿速，可侮也③；廉洁，可辱也④；爱民，可烦也⑤。

凡此五者，将之过也，用兵之灾也。覆军杀将⑥，必以五危，不可不察也。

◎ 白话译文

将帅在性格上有五种致命的缺点：只知一味死拼的，可能被诱杀；贪生怕死的，可能被俘虏；急躁易怒、刚忿偏激的，可能被敌人凌侮而妄动；矜于名节、过分自尊的，可能落进敌人侮辱的圈套而失去理智；过于仁慈的，可能被敌烦扰而陷于被动。

以上这五点，都是将领性格上最容易出现的缺陷，也是用兵的大害。军队覆灭、将帅被杀，可能是由这五种因素所引起的，因此做将帅的人是不能不清楚认识的。

① 必死，可杀也：拼死而无谋，易招杀。
② 必生，可虏也：临阵贪生，易于被俘。
③ 忿速，可侮也：急躁易怒，易莽撞轻进致败。
④ 廉洁，可辱也：廉洁自尊，受辱易愤而出战。
⑤ 爱民，可烦也：仁爱人民，易受困被动。
⑥ 覆军杀将：军队覆灭，将帅被杀。

There are five fatal weaknesses of a general. He who is brave but not resourceful and only knows how to put up a desperate fight will easily be killed; he who is cowardly on the eve of a battle will easily be captured; he who is quick-tempered will easily be provoked into rash moves; he who has too delicate a sense of honor is liable to be shamed and driven to reckless action; he who is too benevolent and loves his people is liable to become hesitant and passive.

These five fatal weaknesses are all the general's faults which will be ruinous to military operations. The destruction of the whole army and the slaughter of the commanders are the inevitable results of these five fatal weaknesses. Therefore, generals must not treat them lightly.

行军篇

（一）

孙子曰：凡处军①相敌②，绝山依谷③，视生处高④，战隆无登⑤，此处山之军也。

绝水必远水⑥；客绝水而来，勿迎之于水内，令半济⑦而击之，利；欲战者，无附于水而迎客⑧；视生处高，无迎水流⑨，此处水上之军也。

绝斥泽⑩，唯亟去无留；若交军于斥泽之中，必依水草而背众树，此处斥泽之军也。

平陆处易，而右背高⑪，前死后生，此处平陆之军也。凡此四军之利，黄帝之所以胜四帝也。

◇ 白话译文

孙子说，凡是军队行军作战和观察判断敌情，应该注意下面一些原则：在通过山地时要靠近有水、草的谷地；军队驻扎时，要选择"生地"，即居高向阳地带；如果敌人已经占据高地，不要仰攻。这些是在山地行军作战的处置原则。

横渡江河，要在离江河稍远的地方驻扎；如果敌军渡河前来进

① 处军：部署军队。
② 相敌：观察敌情。
③ 绝山依谷：绝，经过。越高山时傍溪谷而行。
④ 视生处高：视生，向阳。处于居高向阳之地。
⑤ 战隆无登：敌在高处不应仰攻。
⑥ 绝水必远水：过江河须驻军于离水稍远之处。
⑦ 半济：渡水及半途。
⑧ 无附于水而迎客：勿于近江河之地与敌交锋。
⑨ 无迎水流：不可于下游宿营。
⑩ 绝斥泽：越过盐碱沼泽地带。
⑪ 而右背高：侧翼背后地势须高。

The Army on the March

Sunzi said: A general must observe the following when he deploys troops for battle and investigate the opponent's situation.

Be sure to stay near the valleys when going through mountains; select a place on high ground facing the sunlight for the military camps and do not ascend to fight a battle on high ground. This is the law for taking military position in mountains.

After crossing a river you must stay far away from it. If the enemy attacks from across the river, do not meet him in the water. Instead, it is advantageous to allow half of the enemy's troops to get across and then strike them. If you wish to fight with the enemy, do not go to meet him near a river. Instead, select a place on high ground facing the sunlight for the camps and never encamp in the lower reaches of a river. This is the law for taking up military position in the region of rivers.

Be sure to cross salt marshes quickly with no delay. On encountering the enemy's troops in a salt marsh, keep to those places with plenty of grass with trees to the rear. This is the law for taking up military position in the region of salt marshes.

攻，不要在江河边迎击，而要乘它渡过一半还有一半没有渡过的时候予以攻击，这样比较有利；如果要与敌军交战，那就不要靠近江河迎击它；在江河地带驻扎，也要居高向阳，切勿在敌军下游低凹地驻扎或布阵。这些是在江河地带行军作战的处置原则。

通过盐碱沼泽地带，一定要迅速离开，不宜停留；如在盐碱沼泽地带与敌军遭遇，那就要占领有水、草而靠树林的地方。这些是在盐碱沼泽地带行军作战的处置原则。

在平原旷野地带驻军，要选择地势平坦的地方，最好背靠高处，前低后高。这些是平原地带行军作战的处置原则。

以上四种"处军"原则，是黄帝所以能够战胜"四帝"的重要原因。

Be sure to select an easily accessible place on level ground to pitch camps, with heights to the right and rear, so that the low ground is in front and the high ground behind. This is the law for taking up military position on level ground.

These are the very four laws for encamping and disposing troops which enabled the Yellow Emperor[1] to conquer the four other emperors[2] in ancient times.

[1] Yellow Emperor: It was said that the Yellow Emperor was the father of Han nation.
[2] Four other emperors: Leaders of four tribes in the time of the Yellow Emperor.

(二)

凡军好高而恶下,贵阳而贱阴,养生而处实①;军无百疾,是谓必胜。丘陵堤防,必处其阳,而右背之,此兵之利,地之助也。

◇ 白话译文

但凡驻军,总是喜欢干燥的高地,而尽量避开潮湿低洼的地方,重视向阳处而避开阴暗潮湿的地方,驻扎在便于生活和地势高的地方,就能减少将士患上各种疾病的可能,这是保证军队获胜的一个重要条件。在丘陵、堤防处驻军,一定要驻扎在向阳的一面,并且要背靠着丘陵、堤防。这些对于用兵有利的措施,是地形给予的资助。

① 养生而处实:靠近粮草生长处以便生活,扎营于高地以利居处及交通。

All commanders prefer to station their troops on high ground rather than on low land, in the sunlight rather than in the shade and where food crops can grow and the ground is protected. The troops can be free from diseases and this guarantees victory. If you find hills or dikes, you should station your troops on the sunny side, with the hills or dikes at your back. Such military advantages are afforded by the suitable ground on which you station your troops.

（三）

上雨，水沫至，欲涉者，待其定也。

凡地有绝涧①、天井②、天牢③、天罗④、天陷⑤、天隙⑥，必亟去之，勿近也。

吾远之，敌近之；吾迎之，敌背之。

军行有险阻、潢井⑦、葭苇⑧、山林、翳荟⑨者，必谨覆索之，此伏奸之所处也。

◎ 白话译文

河流上游下暴雨，河水中肯定会有水沫漂来。若想过河，一定要等水沫消失以后再渡河，以防突发山洪。

凡是地形中遇到"绝涧""天井""天牢""天罗""天陷""天隙"等情况，必须迅速避开而不要靠近。

我方远离它，让敌军去接近它；我方面向它，让敌军去背靠它。

军队行军中，遇到山川险阻、芦苇丛生的低洼地、草木繁茂的山林地区，必须谨慎，仔细反复地搜索，因为这些都是敌人容易隐藏伏兵和奸细的地方。

① 绝涧：两岸峭壁，水流其间。
② 天井：四周高峻，中央低洼。
③ 天牢：天险环绕，易入难出。
④ 天罗：草木丛生，难以通行。
⑤ 天陷：低地泥泞，车骑易陷。
⑥ 天隙：山间峡谷，沟坑深长。
⑦ 潢井：积水低地。
⑧ 葭苇：芦苇丛生之地。
⑨ 翳荟：草木繁茂，可隐蔽之处。

If heavy rain falls in the upper reaches of a river and forms torrents rushing down to the lower course, never cross the river but wait until the flood subsides.

When you encounter these dangerous situations, never approach them but avert them quickly: a deep ravine with a violent torrent, a deep gully with dangerous cliffs around, a hemmed-in position as perilous as a prison where it is easy to enter it but difficult to get out, a position which is overgrown with grass and thickets, a low-lying marshy land and a narrow pass between two precipitous mountains.

Keep away from these positions and let the enemy approach them: face them and cause the enemy to put his back against them.

If you find near your camp dangerous defiles, low-lying land overgrown with reeds, or forested mountains with dense tangled undergrowth, you must have a thorough search to see if there are ambushes laid or spies hiding.

(四)

敌近而静者，恃其险也；远而挑战者，欲人之进也；其所居易者，利也①。

◇ 白话译文

敌军离我方很近而仍然保持镇静，是倚仗它具有险要的地形；敌军离我很远而又来挑战，是企图引诱我方前进；敌军之所以舍弃险要地带而居平地，一定有它的好处和用意。

(五)

众树动者，来也②；众草多障者，疑也③；鸟起者，伏也④；兽骇者，覆也⑤。尘高而锐者，车来也；卑而广者，徒来也⑥；散而条达⑦者，樵采也；少而往来者，营军也⑧。

◇ 白话译文

前方树林里很多树木摇动，可能是敌军借助隐蔽而来向我方袭击；在草丛中设有许多遮蔽物，是敌人布下的疑阵，企图迷惑我方。树林里鸟儿突然惊飞，一定是下面藏有伏兵；野兽受惊猛跑，是敌人大军前来突袭。尘埃飞扬而高冲云间，是敌人战车向我方开来；灰尘低而广，是敌人步卒向我方开来；灰尘分散而细长，是敌人在打柴，拖着柴草扬起的尘土；灰尘少而时起时落，是敌军正在察看地形，准备安营扎寨。

① 其所居易者，利也：敌人所处之地对其有利。
② 众树动者，来也：林木动摇，是砍树清道，敌将来袭。
③ 众草多障者，疑也：堆积草木设障，疑有伏兵。
④ 鸟起者，伏也：鸟儿飞起，下有伏兵。
⑤ 兽骇者，覆也：野兽惊跑，敌即来袭。
⑥ 卑而广者，徒来也：尘低而广，为步卒前来。
⑦ 条达：条理分明。
⑧ 少而往来者，营军也：尘少，时起时落，敌扎营垒。

If the enemy's troops are near to your camps and yet they remain composed, it is because their position is advantageous to them. If they are far away from you and yet dare to come and challenge you to battle, it is because they want to seduce you to make an advance. If the enemy stations his troops in a convenient place, it is because there are practical advantages in doing so.

When you find the trees moving, the enemy is advancing towards you. When you find a lot of obstacles hidden among the undergrowth, you know that is the enemy's deception. Birds rising in flight shows there are troops in ambush. Frightened animals scurrying about are a sign of the enemy's imminent attack. Clouds of dust gushing out in high straight columns tell you that the enemy's chariots are approaching. When the dust stays low and is widespread, it is a sign that the enemy's infantry is drawing near. But if the dust is scattered around, it shows that the enemy is cutting firewood. When the dust is low and small and rises intermittently, it indicates that the enemy is going to pitch camps.

(六)

辞卑而益备者,进也;辞强而进驱者,退也;轻车先出居其侧者,陈也;无约而请和者,谋也;奔走而陈兵车者,期①也;半进半退者,诱也。

◇ 白话译文

敌方使者言辞谦卑而实际上又在加紧备战,那是企图要向我方进攻;敌方使者言辞强硬而先头部队又向我方进逼时,可能是要准备撤退;敌方战车先出动,并部署在两侧翼,是在布列阵势,准备作战;敌方没有受挫而突然前来请求议和,其中肯定有阴谋;敌方急速奔跑并排兵列阵,是企图约期同我方决战;敌军半进半退,可能是伪装混乱企图引诱我方前往。

① 期:期待,即敌军准备决战。

When the enemy's messenger speaks humbly while his war preparations continue, the enemy is going to advance. When the enemy speaks uncompromisingly and threatens to advance, he is going to retreat. When the enemy's light chariots set out first and take position on both wings, it signifies that the enemy is arranging his battle formation. When the enemy asks for a truce without advance appointment, it means that he must be plotting. When the generals of the enemy busily move about to arrange the positions of foot soldiers and armed vehicles, that shows the enemy is expecting to launch a decisive attack. When half of the enemy's troops advance and half retreat, that means that the enemy is trying to decoy you.

（七）

　　杖①而立者，饥也；汲而先饮者，渴也；见利而不进者，劳也。鸟集者，虚也②；夜呼者，恐也；军扰者，将不重也③；旌旗动者，乱也；吏怒者，倦也；粟马肉食④，军无悬甀⑤，不返其舍者，穷寇也。

◇ 白话译文

　　敌兵倚仗手中的兵器站立，是饥饿缺粮的表现；从井里打水，敌兵抢着喝，是干渴缺水的表现；敌人见到有好处而不前进，是由于疲劳过度；敌方营寨上有飞鸟停集，说明营寨已空虚无人；敌营夜间有人惊呼，说明敌军心里恐惧；敌营纷扰无秩序，说明其将帅没有威严；敌营旌旗乱动，说明其阵形混乱；敌军官吏急躁易怒，是由于太困倦了。敌人用粮食喂马，杀牲口吃，收起炊具和取水工具，决心不返回营寨，那是准备突围。

① 杖：倚靠着长柄兵器。
② 虚也：兵营空虚，敌或已潜退。
③ 将不重也：敌将无威望。
④ 粟马肉食：粮食喂马，杀牲食肉。
⑤ 甀：盛水器。

When you find the enemy's soldiers leaning on their weapons, you can reason that they have been famished. When you find the enemy's soldiers drink the water they draw before carrying it to the camp, it means that they have been suffering from thirst. And when the enemy sees some profit but does not try to obtain it, it is because he has been completely exhausted. When birds wheel above the enemy's campsite, it suggests that the camp must be unoccupied and the enemy has fled. Clamor from the enemy's camp at night shows that the enemy's troops are terrified and insecure. Disturbance in the enemy's camp means his generals have lost their prestige and authority. When banners and flags are shifted about, confusion must have appeared in the enemy's camp. When lower officers become irritable, they have been weary of war. If the enemy feeds his horses with grain, kills beasts of draught as food for the soldiers, destroys his cooking utensils, and shows no intention to return to the camp, that is to say, he has already determined to fight to death.

(八)

谆谆翕翕①,徐与人言者,失众也;屡赏者,窘也②;数罚者,困也;先暴而后畏其众者,不精之至也;来委谢者,欲休息也③。

◈ 白话译文

敌兵聚集在一起私下低声议论,说明其将领不得众心;再三犒赏士卒,说明敌军已没有别的办法;一再重罚部属,说明敌军陷于困境;将帅先对士卒凶暴后又畏惧士卒叛离,说明其不懂用兵;敌人借故派使者带礼品前来谈判,说明想休兵息战。

(九)

兵怒而相迎,久而不合④,又不相去,必谨察之。

◈ 白话译文

敌军盛怒前来,但久不接战,又不离去,必须谨慎观察,摸清敌人的企图。

① 谆谆翕翕:士卒聚众窃议。
② 屡赏者,窘也:陷于窘境,只能多赏以激励士气。
③ 来委谢者,欲休息也:委派人来赔礼的,是想休兵息战。谢,道歉,谢罪。
④ 不合:不交战。

When soldiers gather together in small groups and complain in a murmur, it betokens that the general has lost their support. A commander who rewards his soldiers too often is in a predicament. He who punishes his soldiers too frequently is in serious distress. If he treats his soldiers violently at first and then fears that they will betray him, he is extremely unintelligent. If the enemy sends a messenger to express his thanks in a mild tone, it indicates that the enemy wishes for a truce.

If the enemy's troops come angrily to meet you and confront yours for a long time, neither fighting nor retreating, you must watch cautiously what they are going to do.

（十）

兵非益多①也，惟无武进②，足以并力、料敌③、取人而已；夫惟无虑而易敌④者，必擒于人。

◈ 白话译文

打仗并不是兵力越多越好，只要不恃勇轻敌、大意冒进，并能集中兵力，判明敌情，做到上下齐心，也就足以战胜敌人了。那种没有深谋远虑而又轻敌妄动的人，势必成为敌人的俘虏。

① 兵非益多：兵不以多为有利。
② 惟无武进：不能恃武轻进。
③ 并力、料敌：集中兵力，察明敌情。
④ 无虑而易敌：无谋而轻敌。

Having more soldiers in war does not give absolute superiority. Never advance recklessly by sheer force, but concentrate your troops through a correct assessment of the enemy's disposition and you will defeat the enemy. He who lacks careful thought and strategy and underestimates the enemy will surely be captured by the opponent.

（十一）

卒未亲附①而罚之，则不服，不服则难用也。卒已亲附而罚不行②，则不可用也。

故令之以文，齐之以武③，是谓必取。令素行④以教其民，则民服；令不素行以教其民，则民不服。令素行者⑤，与众相得也。

◎ 白话译文

将帅在士卒尚未亲近依附时，就贸然处罚士卒，那士卒一定不服，这样就难以使用他们去打仗了。如果士卒对将帅已经亲近依附，将帅仍不执行军纪军法，以纪律去约束他们，这样的军队也是不能打仗的。

所以，要用"文"的手段，即用政治道义教育士卒；用"武"的方法，即用军纪军法来统一步调，这样的军队打起仗来才会战无不胜、攻无不克。平素能认真执行命令、教育士卒，士卒就能养成服从的习惯；平素不严格教令士卒，不明确执行法纪，士卒就会养成不服从的习惯。平时的命令能够认真执行，与士卒们相处融洽，就可以与之共生死。

① 亲附：施恩德使其亲近归服。
② 而罚不行：有刑罚而不严格执行。
③ 令之以文，齐之以武：文，仁恩。武，威刑。恩威并施，则必胜。
④ 令素行：一贯严行法纪。
⑤ 令素行者：法纪贯彻严明者。

When soldiers are rashly punished before they have grown attached to you, they will not obey you. Such troops are naturally very difficult for you to command. If the soldiers have become attached to you, but you exercise no strict nor impartial discipline, you still cannot command them to fight.

You should command your troops with civility and humanity, unify and control them with martial discipline, and you will be invincible. If orders are strictly observed to discipline and instruct the troops, the soldiers will be obedient. Otherwise they will be disobedient. If orders are observed constantly and conscientiously, both the commander and the soldiers will benefit and trust each other.

卷下

孙子兵法

地形篇

(一)

孙子曰：地形有通者①，有挂者②，有支者③，有隘者④，有险者，有远者⑤。

我可以往，彼可以来，曰通。通形者，先居高阳⑥，利粮道，以战则利。

◎ **白话译文**

孙子说：地形有交通便利的，有去时好走回来难走的，有敌我仅相隔于窄路两端的，有很狭窄的，有山川险要、通行不便的，有敌我相距较远的。

我军可以往、敌军可以来的地形叫作"通"。在这种地形作战，应抢先占领高地，保护运送粮草的通道，这样就十分有利。

(二)

可以往，难以返，曰挂。挂形者，敌无备，出而胜之；敌若有备，出而不胜，难以返，不利。

◎ **白话译文**

可以前进、难以后退的地形叫作"挂"。在挂地形上作战，如果敌人没有防备，我军就可以突然攻击，能够获得胜利；若敌人有所准备，出击后不能取胜，加上又难以返回，就很不利了。

① 通者：四通八达。
② 挂者：易入难出。
③ 支者：据险相持均不利进攻。
④ 隘者：山峡间险要之处。
⑤ 远者：敌我相距较远。
⑥ 先居高阳：先占据高向阳之地带。

Terrain

Sunzi said: There are different kinds of terrain in nature. Some terrain is easily accessible, some entrapping, some temporizing, some constricted, some precipitous and some distant.

What terrain is accessible? Ground that is easy for both your troops and the enemy's to move across is called accessible terrain. If you enter the accessible region, you should first take high and sunny positions and keep your supply routes unimpeded. This will benefit you when fighting with the enemy.

Ground that is entrapping is easy for you to enter, but difficult to get out from. In such terrain you make a sally if the enemy is unprepared, and you will defeat him. If the enemy is fully prepared for your coming and you launch an attack, you may not defeat him, and you will have a difficult time getting back. This is the disadvantage.

(三)

我出而不利,彼出而不利,曰支。支形者,敌虽利我①,我无出也;引而去之②,令敌半出而击之,利。

◇ **白话译文**

我军先出击条件不利、敌人先出兵也不利的地形叫作"支";在支形地域上,敌人即使以小利诱我,我军也不要上敌人的当而先出击;应该首先率军撤退,让敌人先出击,待敌人出击一半时反攻,可获胜利。

(四)

隘形者,我先居之,必盈之③以待敌;若敌先居之,盈而勿从④,不盈而从之。

◇ **白话译文**

在两山间有狭窄通谷的隘形地区作战,如果我军先到达,一定要先占领隘口,并派足够的兵力把守,等待敌人来犯;若敌人先占据隘口,并用重兵把守,就不要上前去打,如果敌人只占据了隘口的一部分,并未布兵列阵全部封锁,则可以进攻。

① 敌虽利我:敌即使以利诱我。
② 引而去之:往后撤(以诱敌)。
③ 盈之:重兵把守。
④ 勿从:不要进击。

Ground that is temporizing is disadvantageous for both the enemy and yourself to make a sally. In such terrain even if the enemy offers you an attractive bait, do not make a sally, but pretend to retreat. When his troops are halfway out in pursuit of you, you may strike them. This is the advantage.

If you occupy such a ground that is narrow or constricted, you should block the narrow passes with strong garrisons and wait for the enemy there. If the enemy has taken it first and blocked these narrow passes, you should not make a sally. If the enemy has not blocked them, you may pursue him.

（五）

险形者，我先居之，必居高阳以待敌；若敌先居之，引而去之①，勿从也。

◇ 白话译文

在地形险要的地域上作战，如果我军先占据险地，一定要先控制视野开阔的高地，以等待敌人来犯；如果敌人先占险地，就应该迅速后撤，不要仰攻敌人。

（六）

远形者，势均难以挑战②，战而不利。

凡此六者③，地之道也④，将之至任⑤，不可不察也。

◇ 白话译文

在相距较远的地区作战，双方势均力敌，就不宜上前挑战，勉强求战就会带来不利。

以上六个方面，是利用地形的特点而采取相应措施的规律，掌握这些规律，是将帅至关重要的责任，不能不认真地加以研究。

① 引而去之：宜引退。
② 势均难以挑战：势均力敌，不宜挑战。
③ 六者：指上述六种地形之利害关系。
④ 地之道也：善用地形之规律。
⑤ 将之至任：身为将领应负之重任。

If you first occupy a precipitous ground, you should take a high position on the sunny side to wait for the coming enemy. If the enemy races to control it, you should lead your troops away, and do not make a sally.

If the enemy stations his troops on a distant terrain and his strength matches yours, it is certainly not easy to provoke a battle. Therefore, it is to your disadvantage to sally.

These, then, are the ways to take advantage of six different types of terrain to fight. The generals have the highest responsibility to inquire into them carefully.

(七)

故兵①有走者，有弛者，有陷者，有崩者，有乱者，有北者。凡此六者，非天之灾，将之过也。

◇ 白话译文

军队在打仗的时候有逃跑的，有纪律松弛被打败的，有被俘被杀的，有崩溃的，有乱成一团的，有失败的，这六种是最常见的失败结果。这六种情况的发生，不是天灾地祸，其实是主将的过失造成的。

① 兵：指败阵之兵。

A general should know six situations that point to the defeat of an army: when soldiers take flight, when they have lax discipline, when the army is bogged down by weak soldiers, when it collapses under insurgence, when it is disorganized and when it is routed. None of these situations can be attributed to natural disasters, but instead they are the faults of the generals, which are not inevitable.

（八）

夫势均，以一击十，曰走。卒强吏弱，曰弛①。吏强卒弱，曰陷②。大吏怒而不服，遇敌怼而自战③，将不知其能，曰崩。将弱不严，教道不明，吏卒无常④，陈兵纵横，曰乱。将不能料敌，以少合众⑤，以弱击强，兵无选锋⑥，曰北⑦。

凡此六者，败之道也，将之至任，不可不察也。

◎ 白话译文

 凡是双方势均力敌，却以一击十的一方必然败逃，这叫作走兵。士卒强悍，军官懦弱，指挥松弛，叫作弛兵。军官强悍，士卒懦弱，战斗力差，叫作陷兵。部将怨怒，不服从指挥，遇到敌人必然会因心怀不满而擅自带领所属部队去单独出战，主将又不了解他们的能力而加以限制，必然崩散，叫作崩兵。将领无能，不能严格约束部队，教导训练没有明确的理论、方法，官兵不懂规矩，陈兵布阵时杂乱无章，叫作乱兵。将领不能判断敌情，用少量军队抵抗敌军主力，以弱击强，行阵又无精锐的前锋，叫作北兵。

 这六种情况，都是导致失败的原因，将帅对此有重大的责任，不能不认真地加以研究。

① 弛：军政弛坏。
② 陷：士兵懦弱，陷于亡败。
③ 怼（duì）而自战：意气用事，擅自出战。怼，怨恨。
④ 吏卒无常：将官士卒法纪无常。
⑤ 以少合众：以少兵击众敌。
⑥ 选锋：选精锐为先锋。
⑦ 北：败北。

When conditions and military strengths are equal between you and your enemy, if your army has to fight one ten times its size, the result is your flight. When soldiers are brave and skilled, but officers are weak and incompetent, the whole army will be lax in discipline. When officers are valiant and competent, but soldiers are weak and untrained, the army will be bogged down. When some senior officers have grudges against the commander, they are insubordinate. When they encounter the enemy, they rush into battle without authorization. If at the same time, the commander is ignorant of their abilities, the army will collapse. When the commander is weak, incompetent and fails to command respect, when officers and soldiers behave in an undisciplined way, lacking proper training and clear instructions, when military formations are disorderly, the army is in serious disorganization. If a commander fails to estimate the enemy's strength, uses a small force against a large army, fights the strong enemy with his weak troops and at the same time does not select crack units as vanguards, the result is rout.

All these six situations are the causes of defeat. It is the most important responsibility of a commander to study them with great care.

(九)

夫地形者,兵之助也①。料敌制胜,计险厄远近②,上将之道也。知此而用战者必胜,不知此而用战者必败。

故战道必胜③,主曰无战,必战可也;战道不胜,主曰必战,无战可也。

故进不求名,退不避罪,唯人是保,而利合于主④,国之宝也。

◇ 白话译文

地形是用兵的辅助条件。判断分析敌人的意图,制订取胜的作战计划,首先要考察地形的险易,计算行军路程的远近,这些是主将必须履行的职责。知道这些因素后再指挥作战的人必然会取得胜利,不懂得这些道理就去指挥作战的人必败。

所以从战争的规律上看,那些必然会胜利的,就算是君主下令不战,主将也可以坚持去打;如果按战争实况的发展,没有任何胜利条件,虽然国君说一定要打,主将也可以坚持不打。

总之,进攻敌人不求虚名,撤退防守不避罪名,只一心想保护人民,有利于君主,这样的将帅才是国家的栋梁。

① 兵之助也:可助用兵。
② 计险厄远近:厄,险地。考察地形险易,估计路途远近。
③ 战道必胜:按战争规律必胜。
④ 唯人是保,而利合于主:唯有保民而利于君主。

Terrain is an important aid to a commander in military operations. Correctly estimating the enemy's situation, creating conditions to win, and carefully calculating the dangerous grounds and distances are the basic duties of a wise commander. He who knows these and can apply them in war will definitely win; he who is ignorant of these and cannot employ them in war will certainly lose.

If, in the light of the prevailing situation, fighting is sure to result in victory, a wise commander will decide to fight even if the sovereign tells him not to. Conversely, if the situation points to defeat, he will decide not to fight even if the sovereign orders him to.

Therefore, a great commander advances, without seeking personal fame and gain, retreats without shirking responsibility, aims at protecting the safety of the people and promotes the interests of the sovereign. Such a commander is a gem of the state.

(十)

视卒如婴儿,故可与之赴深溪①。视卒如爱子,故可与之俱死。厚而不能使②,爱而不能令,乱而不能治,譬若骄子,不可用也。

◇ 白话译文

将帅看待士卒如同关心婴儿一样,士卒就可以同他共赴深渊。看待士卒如同亲生儿子,士卒就可以与他同生死、共患难。如果溺爱士卒却不能任用他们,违法乱纪而不能惩治,士卒就如同娇惯的儿子,是不可以用来打仗的。

① 故可与之赴深溪:(士兵)可与将领共死生。深溪,危险之地。
② 厚而不能使:厚待士卒而不能任用。

If a general cares for his men as he does infants, they will follow him through thick and thin. If he dearly loves his men as he does his own beloved sons, they will be willing to die with him in battle. If a general indulges his men but does not know how to use them, loves them but cannot command them, and when they violate laws and regulations, he fails to punish and manage them, such soldiers are like spoiled children and will be useless for battle.

（十一）

知吾卒之可以击，而不知敌之不可击，胜之半也①；知敌之可击，而不知吾卒之不可以击，胜之半也；知敌之可击，知吾卒之可以击，而不知地形之不可以战，胜之半也。

故知兵者，动而不迷②，举而不穷③。

故曰：知彼知己，胜乃不殆④；知天知地，胜乃不穷⑤。

◇ 白话译文

知道我方的士卒可以进攻，而不知道敌方不可以攻击，胜利的可能性仅为一半；知道敌方可以进攻，而不知道我方士卒不可以进攻，胜利的可能性也只有一半；知道敌方可以进攻，知道我方士卒可以进攻，但不知道地形不利于作战的，胜利的可能性还是一半。

所以懂得用兵的人，他的行动准确而果断，他的举措随机应变，变化无穷。

因此，了解对方又知道自己，争取胜利也就不会有什么危险；通晓天时地利，方可百战百胜。

① 胜之半也：只有一半的把握取胜。
② 动而不迷：行动不迷失方向。
③ 举而不穷：措施变化无穷。
④ 殆：危险。
⑤ 胜乃不穷：方可百战百胜。

A general, who only knows his troops' ability to launch an attack but does not know the enemy's invulnerability, will only have half the chance of victory. He who only knows the enemy may be defeated but does not know his own troops' inability to fight, will also only have half the chance of victory. If he knows that the enemy can be defeated and that his own troops have the ability to strike, but does not know if the lay of the land makes it unsuitable for battle, his chance of winning is also merely half.

So a general who is skilled in military operations moves his troops without losing his direction and purpose and acts with unlimited resources and adaptations.

So it is said: know both the enemy and yourself and you will win victory with no danger; know both weather and geographical conditions and you will be ever victorious.

九地篇

(一)

　　孙子曰：用兵之法，有散地，有轻地，有争地，有交地，有衢地，有重地，有圮地，有围地，有死地。

◇ 白话译文

　　孙子说：根据一般的战争法则，地形地理可以分为"散地""轻地""争地""交地""衢地""重地""圮地""围地""死地"。

The Nine Varieties of Ground

Sunzi said: Ground can be classified into nine geographical positions according to the way of using military operations. They are: dispersive ground, frontier ground, contentious ground, open ground, focal ground, serious ground, difficult ground, encircled ground and desperate ground.

(二)

诸侯自战其地,为散地①。

入人之地而不深者,为轻地②。

我得则利,彼得亦利者,为争地。

我可以往,彼可以来者,为交地③。

诸侯之地三属④,先至而得天下之众者。为衢地⑤。

入人之地深,背城邑多者,为重地⑥。

行山林、险阻、沮泽,凡难行之道者,为圮地⑦。

所由入者隘,所从归者迂,彼寡可以击吾之众者,为围地。

疾战则存,不疾战则亡者,为死地。

◇ 白话译文

战争发生在诸侯国自己国境内的某一地区,称为散地。

进入其他国家国境不深的地区,称为轻地。

我军得到有利,敌军得到也有利的地方,称为争地。

我军可以去,敌军可以来的地区,交通方便,四通八达,称为交地。

处在几国交界之处,先到达可以结交周围诸侯,能取得多方援助的地区,称为衢地。

深入敌境,背后有很多敌人城池的地区,称为重地。

山岭、森林、险要、阻塞、水泽、湖沼等难于行走的地方,称

① 散地:诸侯于其领地作战,士兵思家易溃散。
② 轻地:入敌国未深,士兵思家易轻易退却。
③ 交地:道路交错,往来方便之处。
④ 三属:三国交界之处。属,连接之意。
⑤ 衢地:有大道通各国之处。
⑥ 重地:深入敌境,隔着很多敌国城邑的地区。
⑦ 圮地:水毁难行称"圮"。

When a prince wages a campaign in his own territory, the place is called dispersive ground①.

The enemy territory which he enters, but not deeply, is called frontier ground②.

The position that is favorable for both the enemy and yourself to occupy is called contentious ground.

The position that is accessible to both sides is called open ground.

A position, where three neighboring states meet, and which whoever first gets control of will gain the support of other neighboring states, is called focal ground.

When a prince penetrates deeply into hostile territory, having passed through many enemy cities and towns, he is in serious ground③.

A place with interlocking mountains, tangled forests and impenetrable marshes or any place that is hard to travel through is called difficult ground.

① Dispersive ground: Here both officers and soldiers long to return to their nearby homes.
② Frontier ground: Here the soldiers can all get back home easily.
③ Serious ground: It is difficult for soldiers to return home from this ground.

为圮地。

进兵道路狭隘，退回的道路迂远，敌军以少数兵力即可击败我方军队的地方，称为围地。

拼命作战还有可能生存，不拼命作战就肯定会灭亡的地方，称为死地。

A place to which access is constricted and from which return requires making a detour, so that a small troop will suffice to defeat a large army, is called encircled ground.

Such a place where a desperate and speedy battle will save you or else you will be defeated and destroyed is called desperate ground.

（三）

是故散地则无战，轻地则无止①，争地则无攻，交地则无绝②，衢地则合交③，重地则掠④，圮地则行，围地则谋，死地则战。

◇ 白话译文

所以说，在"散地"不宜交战，在"轻地"不要停留，在"争地"不要贸然进攻，在"交地"行军序列不要断绝，在"衢地"应结交诸侯，在"重地"要掠取粮草，遇到"圮地"要迅速通过，陷入"围地"就要运谋设计，千方百计突围，到了"死地"就要殊死奋战，死中求生。

① 无止：不宜停留。
② 无绝：联络不宜断绝。
③ 合交：加强与诸侯国交往。
④ 掠：深入敌区，掠取粮草以维持补给。

As a conclusion, never fight in dispersive ground; never stop in frontier ground; never attack the enemy who first reaches contentious ground; never allow the army's communication to be blocked in open ground; form alliances with neighboring princes in focal ground; plunder for provisions if arriving at serious ground; pass through swiftly, if you meet difficult ground: devise plans to escape in encircled ground; and fight a last-ditch battle in desperate ground.

(四)

所谓古之善用兵者,能使敌人前后不相及,众寡不相恃①,贵贱②不相救,上下不相收③,卒离而不集,兵合而不齐。

合于利而动,不合于利而止。

敢问:"敌众整而将来,待之若何?"

曰:"先夺其所爱④,则听矣。"

◇ 白话译文

古时善于指挥作战的人,能使敌人前后部队失去联系,从而不能相互呼应,主力与小部队不能相互协同配合,官兵不能相互救援,上下级无法相互统属,士卒离散而不能集中,对阵交战阵形也不整齐。

能造成有利于我方的局面就打,不能造成有利于我方的局面就停止行动。

或许有人问:"敌人人数众多、阵势严整地向我方开来,用什么办法对待?"

回答是:"先夺取敌人爱惜不肯放弃的物资或地盘,就能使它陷于被动,从而使敌人听从我军的调动。"

① 众寡不相恃:主力与分支不能相互依靠。
② 贵贱:官卒。
③ 上下不相收:上下不能呼应。
④ 所爱:敌方重地。

In ancient times the generals who were skilled in military operations knew clearly how to make the enemy lose contact between the van and the rear, prevent his main body of soldiers and small divisions from cooperation, make it impossible for the superiors and the subordinates to support each other and communicate with each other, scatter the enemy soldiers so that they could not concentrate, and keep them in disorder even if they were assembled.

The skilled generals would advance when it was to their advantage and halt when situations were unfavorable.

It may be asked, "If the enemy comes to attack you with a large and well-ordered army, how do you deal with it?"

The answer is, "Seize what he cherishes and he will conform to your desires."

(五)

　　兵之情主速，乘人之不及，由不虞之道，攻其所不戒也。

◈ 白话译文

　　用兵的道理，贵在神速，乘敌人措手不及，走敌人意料不到的道路，攻击敌人没有戒备的地方。

The essence of military operations is speed, taking advantage of the enemy's unpreparedness, going by routes he does not expect and attacking him where he is not on guard.

（六）

凡为客①之道，深入则专②，主人不克③；掠于饶野，三军足食；谨养而勿劳，并气积力；运兵计谋，为不可测④。

投之无所往，死且不北⑤，死焉不得⑥，士人尽力。兵士甚陷则不惧，无所往则固，深入则拘⑦，不得已则斗。

是故其兵不修而戒，不求而得，不约而亲，不令而信。禁祥去疑⑧，至死无所之。

吾士无余财，非恶货也；无余命，非恶寿也。

令发之日，士卒坐者涕沾襟，偃卧者涕交颐。投之无所往，诸、刿⑨之勇也。

◎ 白话译文

大凡对敌国采取进攻作战，其规律是：越深入敌境，军心士气越牢固，敌人越不能战胜我军；在丰饶的田野上时，要掠取粮草，使全军得到足够的给养；谨慎休养战士的体力，不要使自己的士兵过于疲劳，要想办法提高他们的士气，养精蓄锐；部署兵力，巧设计谋，使敌人无法判断我军企图。

把部队置于无路可走的绝境，士卒就只能拼命往前冲锋，虽死也不会败退。既然士卒宁死不退，又哪有不打胜仗的道理？士卒深陷险境反而不会恐惧，无路可走，军心就会稳固，深入敌国，我军士兵行动就轻易不敢散漫，处于这种迫不得已的情况，军队就会奋起战斗。

① 客：入敌国作战之客军。
② 深入则专：深入敌境，军心专一。
③ 主人不克：被攻一方不能退来犯之军队。
④ 为不可测：使敌人难测动向。
⑤ 投之无所往，死且不北：置于无路可走之境，士卒宁死不退。
⑥ 死焉不得：不怕死则无不可得。
⑦ 深入则拘：深入敌国，军心专一不涣散。
⑧ 禁祥去疑：禁迷信，去疑惑。
⑨ 诸、刿：春秋时期吴国的勇士专诸、鲁国的武士曹刿。

The principles for making war in the enemy state are as follows. When you penetrate deeply into hostile territory, your soldiers will be united and single-minded, and it will be impossible for the defenders to defeat you. If you enter fertile land, you should plunder it for enough provisions for your men. Nourish them and do not exhaust them; keep them in high morale and conserve their energy; direct your troops with ingenious tactics so that the enemy cannot see through your plan.

You should throw your soldiers into a position from which there is no retreat, and where they will not flee even when facing death. Now that the soldiers are not afraid of death, there will be nothing for them to fear. Both officers and soldiers will do their uttermost to fight. Soldiers deep in a dangerous territory will become fearless, there is no road for them to retreat, they will stand firm. Stuck in the enemy's land, they are bound together. As there is no choice, they cannot but fight a desperate battle.

Soldiers as these need no training to be vigilant. They will do what you want them to do before you ask them, they will cooperate closely before you condition them and they will consciously follow your direction before you order them. You should prohibit superstition and dispel rumors and suspicion among your soldiers, then they will not desert the army even in the face of death.

因此，在这种情况下的军队，无须整治，就懂得要加强戒备；无须强求，都愿意出力；无须约束，就能团结一致，亲密协作；不用三令五申，也都会遵守纪律。在军队中禁止搞迷信活动，以免出现不祥的预兆，引起不好的情绪；消除士兵的疑虑，他们至死也不会退避。

我军士兵没有多余的钱财，不是他们不喜爱财物；我军也没有贪生怕死的士卒，不是他们不想活命。

作战命令发布的时候，坐着的士兵们泪湿衣襟，躺着的泪流满面。把他们放到无路可走的绝境，他们就会像专诸和曹刿一样勇敢。

Soldiers have no surplus wealth not because they have a dislike for possessions; they are fearless of death not because they have a dislike for longevity.

On the day the army is ordered to make a decisive battle, soldiers may sit crying with tears wetting their garments, some may lie down there with tears flowing down their cheeks[1]. But if you throw them into a position where there is no way for them to retreat, they will be undaunted, as brave as Zhuan Zhu or Cao Gui[2].

[1] Soldiers weep because they are so stirred.
[2] Zhuan Zhu and Cao Gui are both famous heroes in the Spring and Autumn Period.

（七）

故善用兵者，譬如率然；率然者，常山之蛇也。击其首则尾至，击其尾则首至，击其中则首尾俱至。

敢问："兵可使如率然乎？"

曰："可。"

夫吴人与越人相恶也，当其同舟而济，遇风，其相救也如左右手。是故方马埋轮①，未足恃也；齐勇若一，政之道也；刚柔皆得②，地之理也。

故善用兵者，携手若使一人③，不得已也④。

◇ 白话译文

所以善于用兵的将帅，能使部队像"率然"蛇一样。"率然"是常山的一种蛇。这种蛇，当你打它的头部时，尾巴就来救应；打它的尾巴，头就过来救应；打它的腹部，头尾都来救应。

有人问："军队可指挥得像'率然'一样吗？"

回答说："可以。"

吴国人与越国人是互相仇恨的，当同船共渡同遇大风时，他们相互救助如同左右手。因此，用缚捆马匹、深埋车轮的方法，企图防止兵卒逃亡，这种方法是靠不住的；要使部队全体士兵同心协力一齐奋勇作战，就像是一个人一样，在于平时的军政修明，领导得法；要使强弱不同的士卒都能发挥作用，就要依靠灵活运用地形。

所以，善于用兵的将帅，能使部队携手如同一个人一样服从指挥，这是因为战争使他不得不这样啊！

① 方马埋轮：系马成排，埋战车轮，表示坚定不移。
② 刚柔皆得：强弱者均各尽其能。
③ 携手若使一人：指挥千军万马，犹如携一人之手。
④ 不得已也：形势使之然也。

Those who are skilled in military operations should be as dexterous as the *shuairan*, the snake of Mount Chang[1]. If you strike its head, its tail will launch an attack on you; if you hit its tail, its head will strike you; if you beat its body, it will attack with both its head and tail.

It may be asked, "Can troops achieve instantaneous coordination as that snake?"

The answer is, "They can."

Everyone knows that the people of the State of Wu and the people of the State of Yue are foes[2], but when they travel by the same boat caught in a storm, they will help each other just as both the left and the right hands cooperate. So holding the war horses together or burying the chariot wheels is not a reliable way to keep the soldiers together. Uniting the soldiers to fight bravely depends on good management and command. The correct use of geographical situations will make troops bring their courage and ability into full play.

A skillful general should command thousands upon thousands of horses and men as if he were leading a single man who will obey without choice.

[1] Mount Chang: It was anciently known as Mount Heng.
[2] Wu, Yue: Two states of the Zhou Dynasty (about 500 BC).

(八)

将军之事,静以幽①,正以治②。能愚士卒之耳目,使之无知。易其事,革其谋,使人无识;易其居,迂其途,使人不得虑③。

帅与之期④,如登高而去其梯。帅与之深入诸侯之地,而发其机⑤,焚舟破釜,若驱群羊,驱而往,驱而来,莫知所之⑥。聚三军之众,投之于险,此谓将军之事也。

九地之变,屈伸之利⑦,人情之理,不可不察。

◎ 白话译文

统帅军队这种事,要沉着镇静而思维缜密,管理部队严整而有条理。能够蒙蔽士卒的耳目,使他们对于军事行动毫无所知。经常改变作战计划,变更作战部署,使人们无法识破;经常改换驻地,行军故意迂回行进,使人们捉摸不出真正意图。

将帅带领士卒如期去作战,要像登高而抽去梯子一样,使士卒只能向前,不能后退;将帅与士卒深入诸侯重地,捕捉战机,发起攻势,像射出的箭矢一样勇往直前。烧毁船只,砸破饭锅,指挥士卒如同驱赶羊群,把他们赶过来,赶过去,使他们不知要到哪里去。集中全部兵力,把他们投入危亡的境地,迫使他们拼命去战斗,这就是军队统帅的任务。

如何灵活地运用各种地形,权衡攻守进退的利害关系,部队思想情绪正在发生什么样的变化,都不可不反复详究,留意考察。

① 静以幽:冷静沉着,幽深莫测。
② 正以治:治军公正严明。
③ 不得虑:不知其行动意图。
④ 帅与之期:将帅带领士卒如期去作战。
⑤ 而发其机:如击弩出箭,可往而不可返。
⑥ 莫知所之:不知所向何处。
⑦ 屈伸之利:根据情况而伸缩进退。

In commanding an army, a general must have a mind that is serene and unfathomable. He must administer his troops in an impartial and upright manner. He should keep his officers and soldiers ignorant of his military plans. He changes his arrangements and alters his military plans without anyone knowing. He shifts his campsites and takes circuitous routes without anyone anticipating his purpose.

A general who leads his troops to fight a decisive battle should cut off all means of retreat as if he kicks off the ladder behind the soldiers after they have climbed up a height. When he leads his troops deep into a princedom, he should have the momentum of an arrow that has been released. He burns the boats and breaks the cauldrons to make the soldiers resolute in fighting. He drives his soldiers here and there as freely as he does a flock of sheep without anyone knowing where he will go. He assembles his whole army and puts it into dangerous situations. This is what a commander should do.

Varying tactics according to geographical positions, advancing or retreating according to what is advantageous and observing the laws of human nature are what a general must study and examine carefully.

（九）

凡为客之道，深则专，浅则散。去国越境而师者，绝地也①；四达者，衢地也；入深者，重地也；入浅者，轻地也；背固前隘者，围地也，无所往者，死地也。

◇ 白话译文

一般来说进入敌国作战的规律是：进入敌国境内越深，军心就越是稳固，进入敌国境内越浅，军心就越是容易涣散。离开本土穿越国境而去敌国作战，那样的地方可以称为"绝地"；四通八达的地方可以称为"衢地"；进入敌境深的地方可以称为"重地"；进入敌境不远的地方称为"轻地"；背后险固前有狭窄的隘口的地方，称为"围地"；无路可走的地方称为"死地"。

① 绝地也：无退路之地。

The way to make war in the enemy's state is as follows: the deeper your troops penetrate into hostile territory, the more they concentrate their spirit to fight; the less deep they penetrate, the less their will to fight is. Crossing a neighboring country to a battlefield where there is no way for soldiers to return, you are in critical ground. In a position which extends in all directions, you have entered focal ground. Deep in the enemy's territory, you have entered serious ground. Penetrating a little distance, you are in frontier ground. When you arrive at a place with rugged terrain at your back and a narrow pass in front, you are in encircled ground. And when you enter a region where there is no way to retreat, you are in desperate ground.

(十)

　　是故散地，吾将一其志；轻地，吾将使之属①；争地，吾将趋其后②；交地，吾将谨其守；衢地，吾将固其结③；重地，吾将继其食④；圮地，吾将进其涂⑤；围地，吾将塞其阙⑥；死地，吾将示之以不活⑦。

　　故兵之情：围则御，不得已则斗，过则从⑧。

◎ 白话译文

　　所以说，在"散地"上，要统一全军的意志；在"轻地"上，要使队伍相连，营垒相属；在"争地"上，要使后续部队迅速跟进；在"交地"上，更要谨慎防守；在"衢地"上，就要巩固与邻国的联盟；在"重地"上，就要保证军粮的供应；在"圮地"上，就要迅速通过；陷入"围地"，就要注意堵塞缺口；进入了"死地"，就一定要告诉将士死拼才能求生。

　　因此，用兵的原则是，被包围就要合力抵御，不得已时就要拼死战斗，深陷险境时士兵们要非常听从指挥。

① 使之属：队伍相连，营垒相属。属（zhǔ），相连。
② 趋其后：使后续队伍迅速跟上。
③ 固其结：巩固结盟。
④ 继其食：保证军粮供应。
⑤ 进其涂：迅速通过。涂，同"途"。
⑥ 塞其阙：阙，同"缺"，指缺口。
⑦ 示之以不活：示之必死以求生。
⑧ 过则从：陷入险境，士卒无不听从。

Thus, when you are in dispersive ground, you should unify the will of your soldiers; when you are in frontier ground, you should keep the van and the rear linked up; when you are in contentious ground, you should hasten up your rear troops; when you are in open ground, you should defend your camp carefully; when you are in focal ground, you should form strong alliances with neighboring princes; when you are in serious ground, you should ensure a continuous flow of provisions; when you are in difficult ground, you should press forward swiftly; when you are in encircled ground, you should block the points of access or egress; when you are in desperate ground, you must show your soldiers that there is no choice but a last-ditch fight.

So a general must know the psychology of soldiers: they will resist while surrounded, fight desperately while forced to and follow the general while fallen into dangerous situations.

（十一）

是故不知诸侯之谋者，不能预交①；不知山林、险阻、沮泽之形者，不能行军；不用乡导者，不能得地利。四五者②，不知一，非霸王之兵也。

◈ 白话译文

不清楚各诸侯国的意图，就不能与其结交；不熟悉山林、险阻、沼泽等地形的特点，就不能领军作战；不使用向导，就不能得到地利。这几个方面有一方面不了解，都不能算是强大的军队。

（十二）

夫霸王之兵，伐大国，则其众不得聚；威加于敌，则其交不得合。

是故不争天下之交，不养天下之权，信己之私③，威加于敌，故其城可拔，其国可隳④。

◈ 白话译文

强大的军队，进攻大国就能使敌方的军队来不及动员集中；兵威加于敌人，就能使它的盟国不敢与它联合。

所以不必争着与任何国家结交，也不必随意在各诸侯国培植自己的势力，相信自己的力量，多多施恩于自己的民众、士卒，把兵威指向敌国，敌国城池可拔，国都就能被攻下。

① 预交：结交。
② 四五者：四加五为九，指九种地势。
③ 信己之私：信（shēn），同"伸"，伸展，倚靠。倚靠自己的力量。
④ 其国可隳：可摧毁敌国。隳（huī），毁坏，崩毁。

A general who is ignorant of the intention of the neighboring princes cannot form alliances with them; he who is ignorant of the interlocking mountains and tangled forests, dangerous abysses and precipices, swamps and marshes cannot move his troops; he who fails to hire native guides cannot occupy the favorable ground; he who is ignorant of advantages and disadvantages of various battle positions cannot command an army befitting an overlord.

If an overlord's army attacks a strong state, even the strong state cannot collect its strength to resist. Wherever such an army goes, it overawes its enemy and prevents his allies from joining him.

Hence, a state with such an invincible army does not need to seek alliances with other states, nor does it need to establish its power in these states. It only relies on its own actual strength to overawe the enemy, and it will be able to capture the enemy's cities and destroy his state.

（十三）

施无法之赏，悬无政之令①，犯三军之众②，若使一人。犯之以事，勿告以言；犯之以利，勿告以害③。投之亡地然后存，陷之死地然后生。夫众陷于害，然后能为胜败。

◈ 白话译文

实行破格的奖赏，颁发非常的政令，驱使三军部队，就像使唤一个人一样。授给下级任务，不必说明作战意图；让他们执行危险的任务，只告诉他们有利的条件，而不告诉他们不利的条件。把士卒投入危地，才能转危为安；把士卒陷于死地，才能起死回生。军队陷于危境，然后才能转败为胜。

（十四）

故为兵之事，在于顺详④敌之意，并敌一向⑤，千里杀将，此谓巧能成事者也。

◈ 白话译文

所以，领兵作战这种事，就在于假装顺着敌人的意图，集中兵力指向敌人一处，即使千里奔袭，也可斩杀敌将，这就是所说的巧妙运用计谋就可以克敌制胜。

① 施无法之赏，悬无政之令：破例施赏，颁超常规之政令。
② 犯三军之众：指挥三军。犯，驱使。
③ 犯之以事，勿告以言；犯之以利，勿告以害：使士卒作战，不必解释图谋，使士卒知利不知害，以释其疑虑。
④ 详：同"佯"。
⑤ 并敌一向：集中兵力指向敌人。

If you lead an overlord's army, you must bestow rewards irrespective of customary practice and issue orders irrespective of convention, then you can command thousands upon thousands of horses and men as if you were leading a single man. Set your troops to operation but never tell them your plans; use them to gain advantage, but never tell them the dangers and disadvantage involved. Only by throwing an army into a perilous position can they survive; only by putting them in desperate ground can they live. Provided the troops are placed in danger, they will be able to turn defeat into victory.

Success in military operations lies in pretending to follow the enemy's intentions but in fact concentrating your troops to attack one aspect of the enemy. You will be able to kill his commander even if you are a long drive of a thousand *li* away. This is so-called using artful and ingenious plans to accomplish great tasks.

（十五）

是故政举之日，夷关折符①，无通其使，厉于廊庙之上，以诛其事②。敌人开阖，必亟入之③。先其所爱，微与之期④。践墨随敌，以决战事⑤。是故始如处女，敌人开户；后如脱兔，敌不及拒。

◎ 白话译文

当决定对敌作战的时候，就要封锁关卡，废除通行凭证，停止与敌国的使节往来，在庙堂里举行最高军事会议，再三谋划，制定战略决策。一旦发现有机可乘，就马上乘虚攻入。首先要夺取敌人战略要地，不要与敌人约期决战。既要按照原则，又要破除成规，适应敌情变化，灵活指挥自己的作战行动。因而，战争开始要像处女一般沉静，使敌人放松戒备；然后突然发动攻击，要像脱逃的野兔一样迅速快捷，使敌人来不及抵抗。

① 夷关折符：封锁关卡，废除通行证。
② 厉于廊庙之上，以诛其事：于庙堂密议军事策略。诛，治，研究。
③ 敌人开阖，必亟入之：敌有间隙，乘机而入。阖（hé），门扇。
④ 微与之期：隐藏与敌人作战的时间。
⑤ 践墨随敌，以决战事：不墨守成规，应根据敌情变化而行事。

On the day of making a final decision to fight, you should close all passes, abrogate all official tallies[①], and terminate all contact with the enemy's emissaries. Carefully examine your military plans in the temple council[②] and make decisions. If you find out the opponent's weak point, you must break through it speedily. Seize what is most valuable to the enemy first. Don't betray your time of attack to him. In pursuing your plans, modify them according to the enemy's situations in order to win. At first assume the quietness of a maiden and when the enemy gives you an opening, attack him as swiftly as a running hare. This will make the enemy unable to resist you.

① Official tally: In former times each traveler must possess an official pass which was examined by the wardens at the frontiers.
② The temple council: In ancient China, the most important decision must be made in the ancestral temple, which is a religious rite. So the temple is different from military headquarters.

火攻篇

（一）

孙子曰：凡火攻有五：一曰火人，二曰火积①，三曰火辎，四曰火库，五曰火队②。

行火必有因，烟火必素具。发火有时，起火有日。时者，天之燥也；日者，月在箕、壁、翼、轸③也。凡此四宿者，风起之日也。

◇ 白话译文

孙子说，进行火攻一般有五种形式：一是烧毁敌军营寨；二是烧毁敌军堆放的谷物粮草；三是火烧敌军辎重；四是火烧敌军仓库；五是烧毁敌人运送粮草的通道。

实施火攻需要具备一定条件，点火器材必须平日准备好。发动火攻还要看天时，点火要看准日子。天时是指气候干燥的季节，日子是指月亮行经箕、壁、翼、轸四星所在位置的日子。凡月亮经过四星宿的时候，就是起风的日子。

① 火积：焚烧敌军积聚之粮草。
② 火队：焚烧敌军输送粮道。队（suì），同"隧"，通道。
③ 箕、壁、翼、轸：二十八星宿中的四个。据云，月行经此等星宿时多起风。

Fire Attack

Sunzi said: There are five ways of attacking with fire. The first is to burn the enemy troops; the second is to burn their provisions and property; the third, their equipment; the fourth, their arsenals; and the fifth, their transportation lines.

To attack with fire requires some media. Materials for setting fire must always be at hand. There are suitable seasons to launch a fire attack and suitable days for starting a fire. The suitable season for a fire attack is when the weather is dry; the suitable days for setting fire are when the moon is in the position of the constellations of the Sieve, the Wall, the Wing or the Cross-bar[①]. For, when the moon is in those positions, strong winds will rise.

① The Sieve, the Wall, the Wing and the Cross-bar are four of twenty-eight constellations in ancient astronomy of China.

(二)

凡火攻，必因五火之变而应之。火发于内，则早应之于外。火发兵静者，待而勿攻，极其火力①，可从②而从之，不可从而止。火可发于外，无待于内，以时发之③。火发上风，无攻下风。昼风久，夜风止。

凡军必知有五火之变，以数守之④。

故以火佐攻者明⑤，以水佐攻者强⑥。水可以绝，不可以夺⑦。

◇ 白话译文

凡用火攻，必须根据五种火攻所引起的不同变化灵活地派兵接应。从敌营内部放火，就要及时派兵从外部策应。火已烧起而敌营仍然保持镇静，我方要等待观察，不要急于进攻。待到火势旺盛时，可以进攻就进攻，不可以进攻就停止。如果从外面放火，这时就不必等待内应，只要按准确时机放火就行。从上风口放火，不要从下风口进攻。白天风刮久了，夜晚就容易停止。

军队必须懂得灵活运用五种火攻的方法及其变化，然后耐心等候条件，实施火攻。

用火辅助军队向敌人发起进攻，取得胜利就容易得多；用水辅助军队向敌人发起进攻，攻势明显就可以加强。水可以阻隔敌人，但不能直接削弱敌军实力。

① 极其火力：让火势烧到最旺之时。极，尽。
② 从：跟从，此处指进攻。
③ 以时发之：时机适当即可火攻。
④ 以数守之：掌握星宿度数，伺机火攻。
⑤ 以火佐攻者明：以火助攻，胜负分明。
⑥ 以水佐攻者强：以水助攻，只分强弱。
⑦ 水可以绝，不可以夺：水可断绝道路，不能毁灭敌军。

If you employ a fire attack, you must adopt appropriate military response according to different situations caused by five ways of fire attack. When a fire is set inside the enemy's camp, you should coordinate your action from outside in advance. When the enemy's camp is on fire and yet his soldiers remain calm, you should bide your time and do not launch an attack. When the flames reach a height, you may follow it up with an attack if you can, and do not if you cannot. When a fire can be set from outside the enemy's camp, you need not wait until it is started inside, but you should select a suitable time to set fire. If you start a fire from up-wind, never launch an attack from down-wind. The wind that continues blowing during the day is likely to subside at night.

Any army must know about the varying situations under the five ways of fire attack and keep waiting for suitable time.

So a general who uses fire to assist his attack will be sure to win; he who uses water to assist his attack only shows that he is strong. Water may stop the enemy from moving forward, but cannot deprive the enemy of his impedimenta.

（三）

夫战胜攻取，而不修其功者凶①，命曰费留②。故曰：明主虑之，良将修之。非利不动，非得不用③，非危不战。

主不可以怒而兴师，将不可以愠而致战。合于利而动，不合于利而止。怒可以复喜，愠可以复悦，亡国不可以复存，死者不可以复生。

故明君慎之，良将警之。此安国全军之道也。

◇ 白话译文

凡打了胜仗，夺取了土地城邑，而不能巩固战果的，则很危险，这叫白费力气。所以说，明智的国君要慎重地考虑这个问题，贤良的将帅应该认真地研究这个问题。无利可图就不要采取军事行动，没有必胜的把握就不要用兵，不处在十分危险的时机就不要开战。

国君不可因一时愤怒而发动战争，将帅不可因一时气愤而出阵求战。符合国家长远利益就行动，不符合国家长远利益就停止。愤怒可以转化为高兴，恼火可以转化为喜悦，但国家灭亡却不能再恢复，死掉的人也不可能再活过来。

因而，对于战争，明智的国君要慎重地对待，优秀的将帅要保持警惕，这是安定国家和保全军队的根本原则！

① 而不修其功者凶：打了胜仗而不论功行赏巩固成果者则招致凶险。
② 费留：白费时间和力气。
③ 非得不用：不做无把握之事。

To win a battle and capture the spoils but then fail to consolidate such achievements forebodes danger, for it is a waste of time and effort. An enlightened sovereign must know how to deliberate upon this problem and a good general should carefully deal with it. If it is not advantageous, never send your troops; if it does not yield success, never use your men; if it is not a dangerous situation, never fight a hasty battle.

A sovereign should not wage a war simply out of anger, nor should a general dispatch his troops to fight simply out of indignation. When it is favorable to you, take action; when it is unfavorable, do not act. Generally speaking, a man who is enraged will in time become happy, and he who is indignant will again become pleased, but a state that has perished can never revive, nor can a man who has died be brought back to life.

Therefore, an enlightened sovereign should handle the matter of war in a prudent way, and a good general treat war with caution. This is the way that keeps the state in peace and security, and the army intact.

用间篇①

（一）

孙子曰：凡兴师十万，出征千里，百姓之费，公家之奉，日费千金；内外骚动，怠于道路，不得操事者，七十万家②。相守数年，以争一日之胜，而爱爵禄百金，不知敌之情者③，不仁之至也，非人之将也，非主之佐也，非胜之主也。

故明君贤将，所以动而胜人，成功出于众者，先知也。先知者，不可取于鬼神，不可象于事④，不可验于度⑤，必取于人，知敌之情者也。

◇ 白话译文

孙子说：凡是打仗要用兵十万，出征千里，老百姓的耗费，国库的开支，算起来每天平均要花费千金之多；并且给全国内外带来动乱和不安，运输军需物资的队伍和行军的兵卒疲惫地在道路上来回奔走，因而不能安心从事耕作的大约有七十万人家。双方相持数年，是为了争取一朝决战时的胜利，如果却因为吝啬爵禄金银，不肯花钱收买间谍和使用间谍，以致不能了解敌方实情而导致失败，可以说是不懂仁爱到了极点！这种人，不配为军中统帅，不配为君主的辅臣，也不是能打胜仗的主帅。

因此，开明的君主、贤良的将帅，之所以动兵打仗就能战胜敌

① 用间篇：用间谍之道。
② 不得操事者，七十万家：据说古时一家从军，七家奉之。举十万之师，则不专事耕稼者达七十万家。
③ 爱爵禄百金，不知敌之情者：吝惜官职钱财，不（用间谍以）了解敌情。
④ 不可象于事：不可以旧事类推。
⑤ 不可验于度：不可凭日月星辰之位置度数推断吉凶。

Use of Spies

Sunzi said: When an army with one hundred thousand officers and soldiers is sent to war a thousand *li* away, the common people and the state treasury together have to spend a thousand pieces of gold every day in support of it. There will be continuous disturbance at home and abroad, and a lot of common people involved with convoys are exhausted from performing transportation services. About seven hundred thousand households[1] will be unable to cultivate their fields. If a general engages his state in a drawn-out war for several years to strive for victory which is decided merely in a single day, and if the general begrudges the expenditure of a hundred pieces of gold in honors and emoluments to employ spies and is thus ignorant of the enemy's situations, he is, of course, completely devoid of humanity. Such a man is not a good general, not a good assistant to his sovereign, and no master of victory.

[1] In ancient China, eight families comprised a community. When one family sent a man to join the army, the remaining seven families contributed to its support. Therefore, when an army of one hundred thousand was raised, those unable to attend fully to their own ploughing and sowing amounted to seven hundred thousand households.

人，成功的次数高于一般的人，就在于他们事先了解敌情。要事先了解敌人的情况，却不能用祈求鬼神去获得，也不可用过去相似的事情去做类比推测吉凶，也不用夜观天象，不用日月星辰运行的轨迹、位置和光亮度数去验证，一定要从那些熟悉敌情的人口中去获取情报。

Therefore, an enlightened sovereign and an able general can defeat the enemy whenever they take action and achieve extraordinary accomplishments because they can foresee the development of war. Such fore-knowledge cannot be obtained from ghosts and spirits, cannot be gained from analogous experiences, and cannot be found by calculating the positions of the sun, the moon and stars. It must be obtained from the people who clearly know the enemy's situations.

（二）

故用间有五：有因间，有内间，有反间，有死间，有生间。

五间俱起，莫知其道，是谓神纪①，人君之宝也。

因间者，因其乡人而用之②。内间者，因其官人而用之。反间者，因其敌间而用之。死间者，为诳事于外③，令吾间知之，而传于敌间也④。生间者，反报也⑤。

◇ 白话译文

所以，使用间谍有五种基本方法：有乡间、内间、反间、死间、生间。

若是五种间谍方法一齐综合使用，敌人就无法知道其中的奥妙，这就变成了一种非常神妙的方法，也是国君制胜的法宝。

所谓"乡间"，就是利用与敌人同乡的人提供情报。所谓"内间"，就是诱使敌方的军官提供情报。所谓"反间"，就是利用敌方派来的间谍，故意提供给他假情报，使其反而为我方效力。所谓"死间"，就是故意在外面散布假情报，并通过潜入敌营的我方间谍传给敌人。所谓"生间"，就是能亲自带回敌方情报的我方间谍。

① 神纪：神妙莫测之道，纪，即"道"。
② 因其乡人而用之：利用敌方乡人为间谍。因，利用。
③ 为诳事于外：故意散布虚假情况以欺骗敌人。诳，迷惑欺骗之言。
④ 令吾间知之，而传于敌间也：使我方间谍知情而传与敌人，常因而牺牲，故曰死间。
⑤ 反报也：安全返回报告敌情。

There are five kinds of spies to be used: native spy, inside spy, converted spy, expendable spy and surviving spy.

When you use the five kinds of secret agents simultaneously, the enemy cannot know the principle of their operation. It is divinely intricate and becomes the greatest magic weapon for the sovereign to defeat the enemy.

Native or local spies are those employed from among the enemy's villagers. Inside spies are those employed from among the enemy's officials. Converted spies are those employed from among the enemy spies. Expendable spies are our own secret agents, who deliberately give some false information of ours to report to the enemy. Frequently they would be caught and put to death. Surviving spies are those who come and go between the enemy and us, and return safely with the enemy's information.

（三）

故三军之事，莫亲于间，赏莫厚于间，事莫密于间。

非圣智不能用间，非仁义不能使间，非微妙不能得间之实①。

微哉，微哉！无所不用间也。间事未发而先闻者，间与所告者皆死。

◈ 白话译文

因此，在军队的人际关系中，没有比将帅对间谍更亲密的了；军中的奖赏，也没有比间谍得到的更优厚的了；同样，做事情也没有比间谍更秘密的了。

不具有高智商的人，就不能很好地利用间谍；不是仁慈正直的人，也不能指使间谍行动；没有精微的分析判断能力的人，也不能得到间谍真实的情报。

微妙啊微妙，没有什么地方不可以用间谍。如果间谍的工作还没有开展，却已经泄露了出去，那么间谍以及听到秘密的外人都要处死。

① 非微妙不能得间之实：唯经精细分析始能获得情报之实情。

In regard to trusted followers in the armed forces, none is more intimate than the spies who are close to the general or the commander; of all rewards, none is more generous than those given to spies, and regarding military secrets, none is more confidential than those relating to espionage.

He who is not a sage cannot use spies; he who is not humane just cannot command spies; he who is not careful and subtle cannot get truthful information from spies.

Subtle indeed! Truly subtle! There is no place where espionage is not possible. If a secret plan is divulged prematurely, the spy and those who are told about it shall be put to death.

（四）

凡军之所欲击，城之所欲攻，人之所欲杀，必先知其守将、左右、谒者①、门者、舍人②之姓名，令吾间必索知之。

◇ 白话译文

凡是要攻打敌方军队，要攻破敌方城邑，要刺杀敌方重要人员的时候，必须先打听出守城的将官是谁，以及他左右的亲信、掌管传达通报的官员、守门官吏和门客幕僚的姓名，这些一定要让我们的间谍侦察清楚。

① 谒者：传达通报之官员。
② 舍人：官邸近侍官员。

If you plan to strike an enemy's troops, or attack an enemy's city, or kill an enemy's commander, you must find out first the name of the chief garrison commander, his aides-de-camp, trusted followers, ushers, gatekeepers and bodyguards, and you must instruct your spies to investigate these in detail.

（五）

必索敌人之间来间我者，因而利之，导而舍之①，故反间可得而用也。

因是而知之②，故乡间③、内间可得而使也。因是而知之，故死间为诳事，可使告敌④。因是而知之，故生间可使如期⑤。

五间之事，主必知之，知之必在于反间，故反间不可不厚也。

◇ 白话译文

一定要查出敌方派来的间谍，对他们要不惜重金收买，优厚款待，诱导利用，安排住宿，为我所用，使他们成为"反间"。

从反间了解到敌人内部情况，就能从敌方找到恰当人选，乡间、内间就可以得到使用了。通过反间那里了解了情况，死间就可以散布假情况，并让他告诉敌人。由于从反间那里了解了情况，就能避开危险，生间就可以如期回报敌情。

五种间谍的使用情况，君主都必须掌握，了解敌人情况最主要的在于反间，所以对待反间一定要特别优厚。

① 导而舍之：稽留诱导，再放回令其充当反间。
② 因是而知之：因用反间而掌握情报。
③ 乡间：因间。
④ 死间为诳事，可使告敌：死间将虚假情报传给敌人。
⑤ 可使如期：按预定时限返回报告敌情。

You must detect those enemy spies who have been sent to conduct espionage against you. Bribe them, exhort and release them to serve you. At last they will become converted spies and work for you.

Through these converted spies, you can obtain information about the enemy and recruit native spies and inside spies. In this way, your expendable spies may convey the false information about your army to the enemy. In the same way, the surviving spies you sent to the enemy may return on schedule and give you information.

A sovereign must know how to use the five types of spies. Such knowledge is necessarily derived from the converted spies, so converted spies should be rewarded generously.

(六)

昔殷之兴也,伊挚在夏①;周之兴也,吕牙②在殷。

故惟明君贤将,能以上智为间者,必成大功。此兵之要,三军之所恃而动也。

◇ 白话译文

从前商朝的兴建,是由于伊尹曾经在夏朝生活过;周朝的兴创建立,在于姜尚曾经在商朝生活过。

所以明智的国君和贤能的将帅,都能用高级的、有智慧的人来做间谍,因此而建立大的功业。这就是用兵中非常重要的策略,整个军队都要依靠他提供的情报来决定军事行动。

① 伊挚:伊尹,夏桀王之臣,助殷商灭夏。
② 吕牙:吕尚,即姜子牙。原纣王之臣,后归周,助武王灭纣。

In ancient history, the rise of Yin[①] was due to Yi Zhi, who was former minister of Xia; and the rise of the Zhou Dynasty[②] was due to Jiang Ziya[③], the former minister of Shang.

Therefore, only the enlightened sovereign and the able general can find out and use the intelligent men as spies and achieve great tasks. The use of spies is essential in war, and the army must depend on this in its action.

① Yin: The later period of the Shang Dynasty (16th—11th century BC).
② Zhou Dynasty: 11th—2nd century BC.
③ Jiang Ziya: Alias Lü Ya.

本书译文版权归罗志野先生所有,与本书相关的各项版权事宜请与出版社联系。

电话:010-68359719;联系人:张旭